BEEN THERE
SHOT THAT

To Tracy,
Have fun with your
home + Enjoy!

[signature]
June 2, 2015.

First Edition

Text © 2013 by Hilary Rose

Photography © 2013 by Jenifer Jordan

Designed by Joseph Taylor
Edited by Patt Taylor

ISBN: 978-0-615-84446-6

To purchase additional copies of this book go to www.beenthereshotthat.org

Printed in China

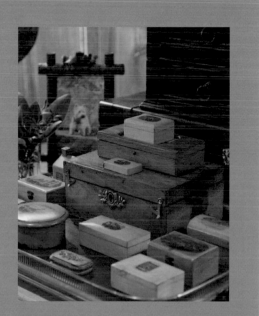

BEEN THERE
SHOT THAT

INTERIOR DESIGN
peared down

Photography by Jenifer Jordan

Written & Produced by Hilary Rose

Graphic Design by Joseph Taylor
Edited by Patt Taylor

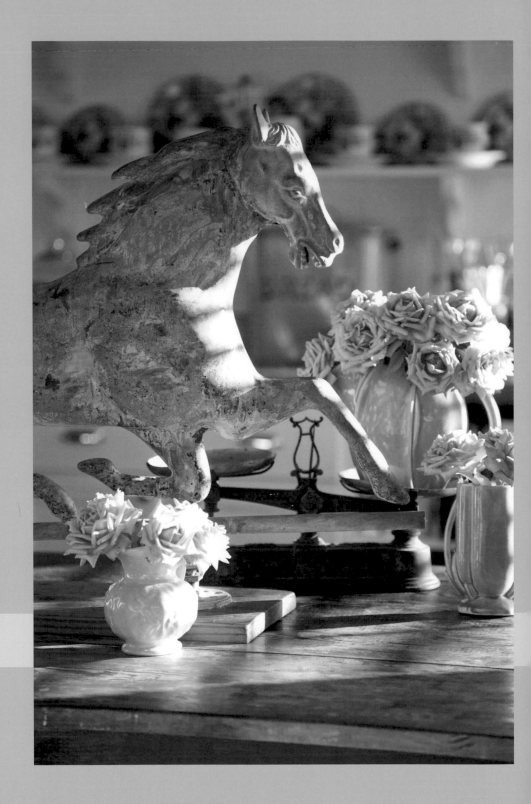

We met on a photo shoot for *Traditional Home* magazine. It was 1986.

We shared a passion for interior design, mid-afternoon chocolate, and end-of-the-day chardonnay.

We haven't changed much over the years. We shoot digital now, and we're both cutting back a little on the chocolate . . . On the other hand, it was time to change the way we talked about design. And so **Been There Shot That** was born. A new kind of design book. With a no-frills point-of-view. Without all the blah blah blah.

No matter your look, whatever your vice, if **Been There Shot That** makes you smile... we'll drink to that!

Have fun!

Jenifer & Hilary

We want to thank our four legged friends who participated in the making of this book. Please know that all were paid handsomely in cookies and cheese.

Designers

Each of these talented designers brings
a unique aesthetic to the world of design.
They also share a passion for beautiful
interiors that never go out of style.

Charles Faudree: *"Too much is never enough."*

Charles Faudree has become synonymous with French Country design.
Internationally known for his work, Charles is a master at combining
fabrics, furnishings, and collections for a look that is as enduring as
it is beautiful.

Denise Macey: *"A home should be inviting, intelligent, soulful and directly reflect the needs and visions of its owners."*

Denise's work is all about nuanced color palettes, luxurious materials
and enriching textures. Balancing classic style with a modern sensibility,
Denise has a vision that is both organic and sophisticated.

Gail Plechaty: *"Sophistication is timeless."*

Gail is known for mixing fabulous antiques with a modern aesthetic.
A minimalist, Gail's interiors are the essence of restraint with a casual
elegance that is new yet timeless.

Andre Walker and David Simmons: *"Design should be interesting, creative, practical, touchable, and most importantly, represent who lives in the home."*

Walker Simmons Designs specializes in transforming ordinary rooms
into elegant living spaces that are personal . . . cozy . . . classic. The
use of color and layering fabrics are central elements in their work.

Jennifer Spak: *"Variety is the key to interesting spaces."*

Jennifer is known for incorporating antique pieces with the latest designer furnishings to create a comfortable atmosphere – with a Southern sensibility.

Annie Uechtritz: *"A well-designed home should tell the story of the people who live there."*

Annie relies on antiques, family heirlooms, and vintage finds to define her interiors. Her passion for pieces that are worn and well-loved brings warmth as well as a sense of history. Annie's style is best described as comfortably eclectic.

In addition to our fabulous designers, we've included some spaces from a few other design talents, because we believe in great ideas – wherever they come from . . .

Page Martin

As a former caterer, Page understands that a beautiful space makes a great meal even better.

Nancy Ingram

Nancy was our dear friend and field editor/stylist, who passed away January 2012. She will be remembered for her inspired sense of design, her great sense of humor, and her inexhaustible spirit.

...and our **Jenifer Jordan**... whose work as a photographer has informed her own sense of style.

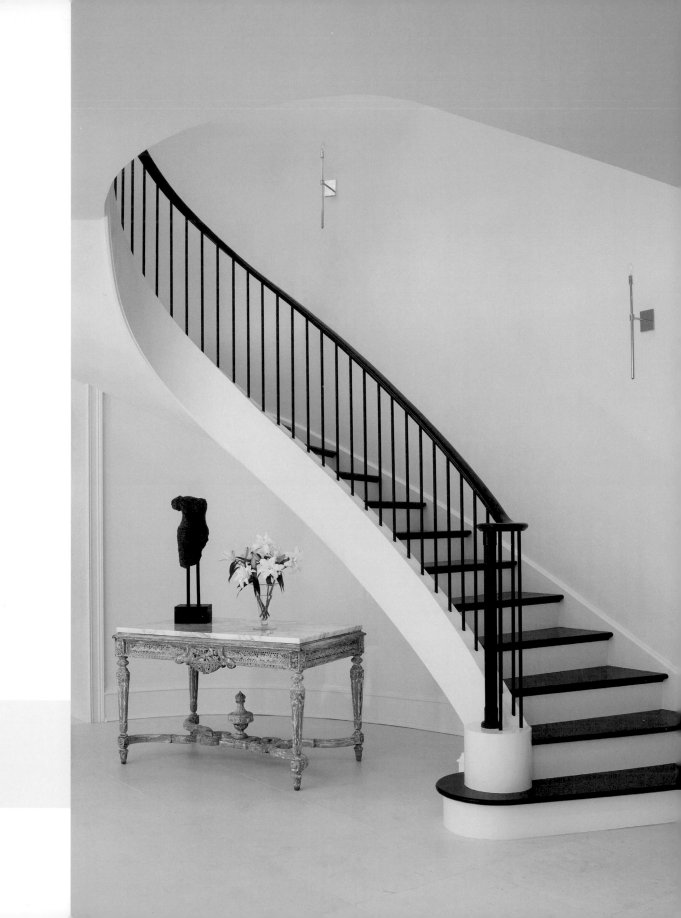

Stairway to Heaven

Elegant and restrained. Gail Plechaty designed this graceful curve of stairs, then played the contrast of the dark wood against the white. A sculptural piece of art. If you've got great architecture
– flaunt it!

Baby
GOT THE
BLUES

Charles Faudree brings an air of sophisticated elegance to this island home. The armoire and armchairs in the style of Louis XVI give it a French twist, while the different fabrics and trims add depth and interest. The clear blue color is as fresh as an ocean breeze.

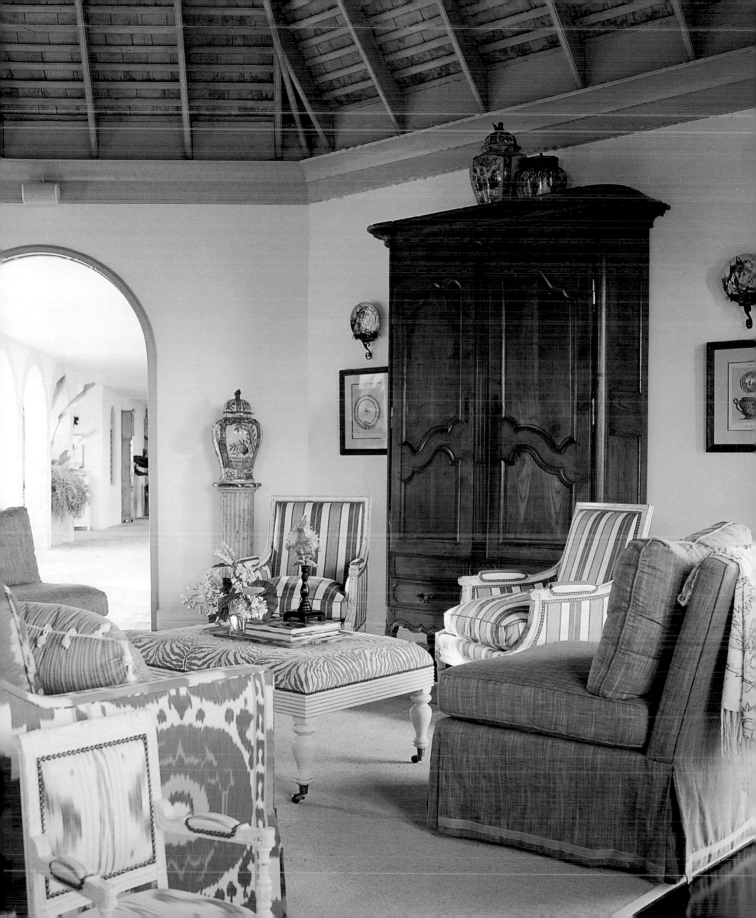

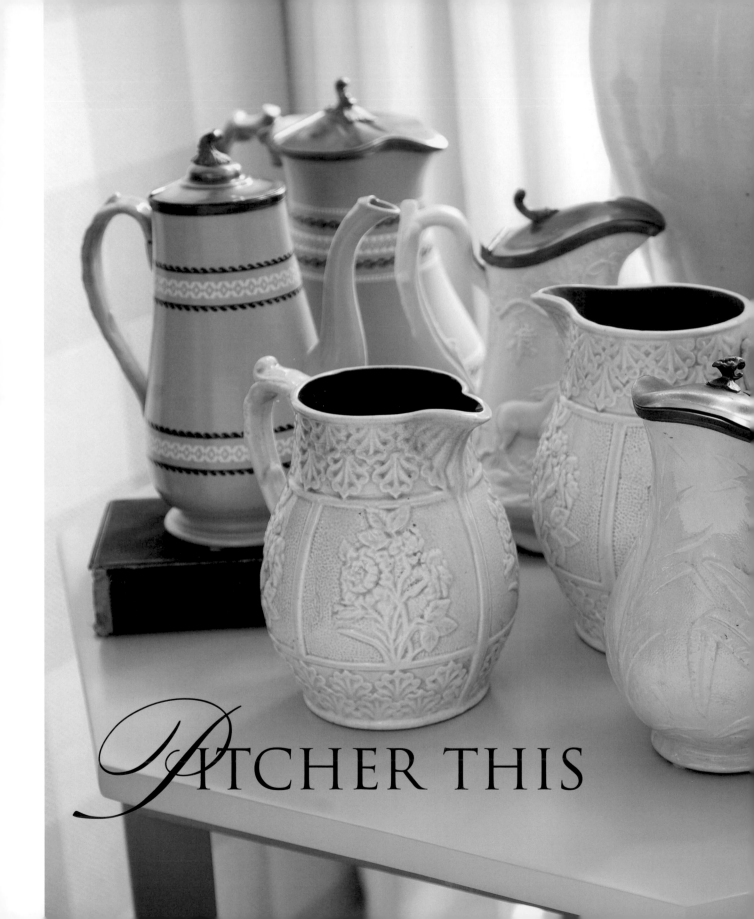

⟨Pitcher THIS

Andre Walker and David Simmons were drawn to a specific shade of blue found in salt glaze English pottery from the 1800's. One pitcher led to another, until they had a group worthy of grouping. And that is how you start a collection.

A PANE IN THE GLASS!

Antique window frames become a focal point in Jenifer Jordan's guest cottage, affording an opportunity for display. Change it for the holidays, for the seasons . . . play with it. Another excuse for Jenifer to go shopping!

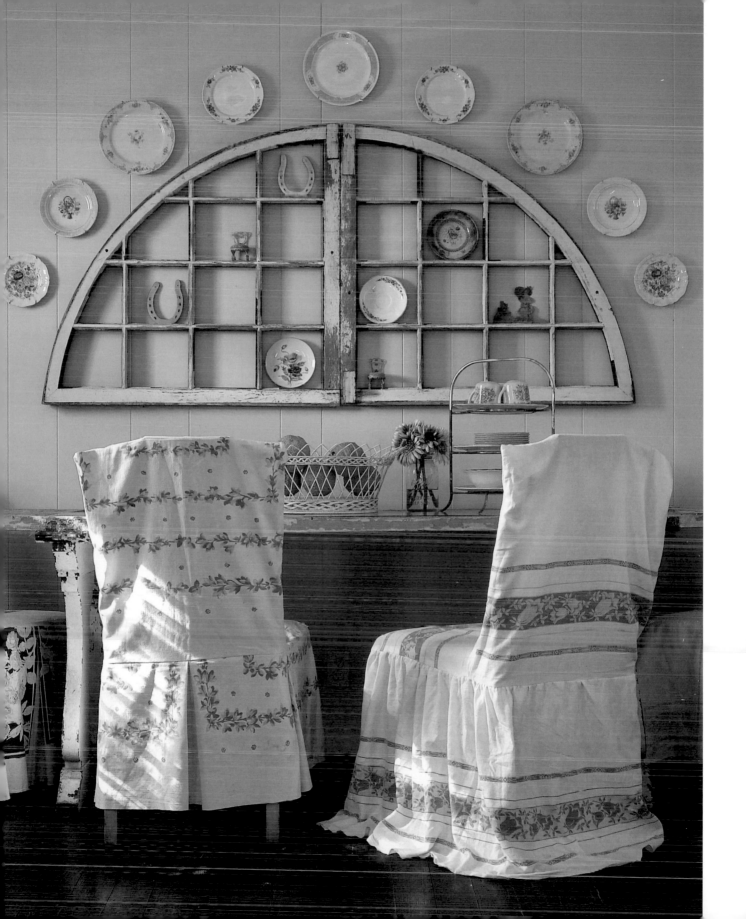

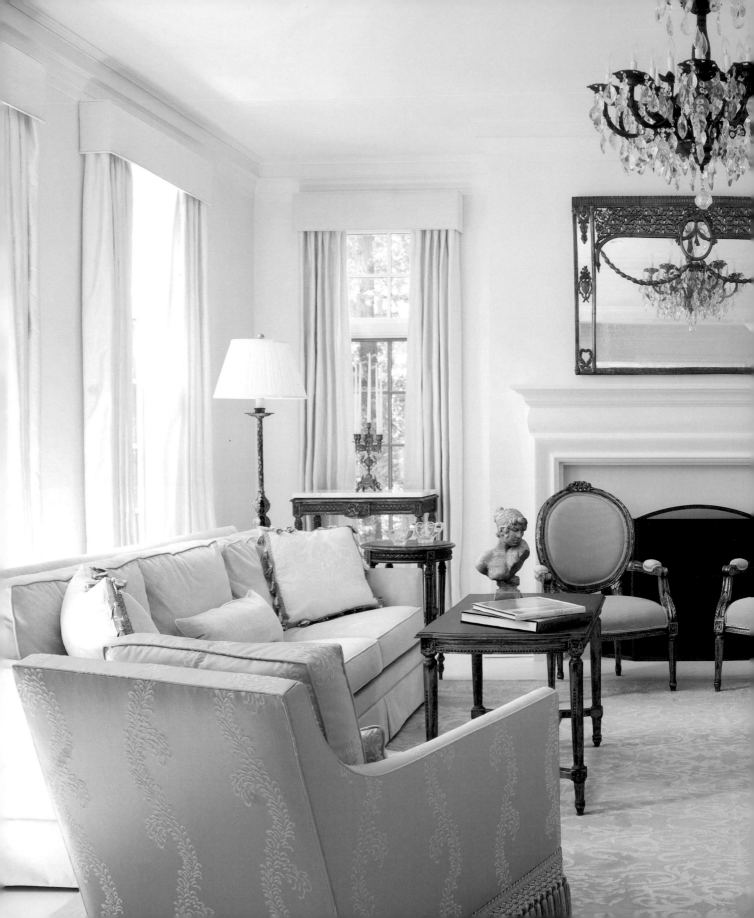

Gail uses symmetry and a monochromatic palette to create a living room that defines understated elegance. From the rigorously edited accessories to the quiet hints of color, this room has an ethereal quality. It's peaceful, sophisticated, and did we say pretty?

Seeing Double

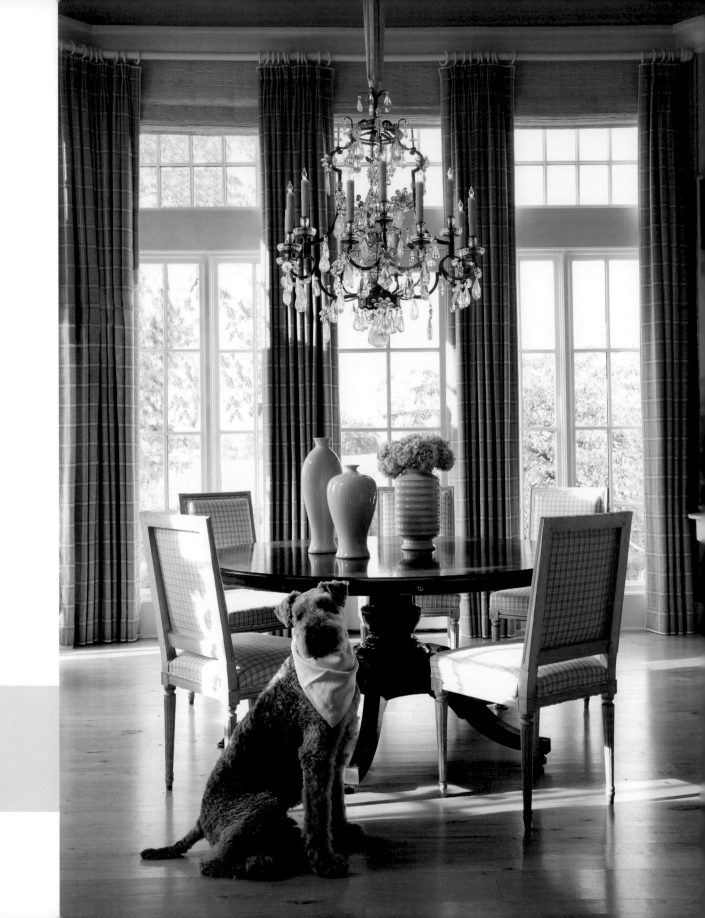

"Did someone say Dinner?"

This dining room by Andre and David boasts a 13-foot ceiling and French doors with transoms, bathing the room in natural light. The linen draperies dramatize the height, and add warmth with color. Someone once said every woman looks prettier in a peach room. We think this terra cotta ceiling would give anyone a glow!

PEARED DOWN

Denise Macey's design aesthetic is big on texture. Here she places an antique Italian grotto table against a stone wall, accessorizing with an old Chinese porcelain bowl filled with smooth alabaster pears. The simplicity of the pieces emphasizes the natural beauty of the materials. Sometimes less *is* more.

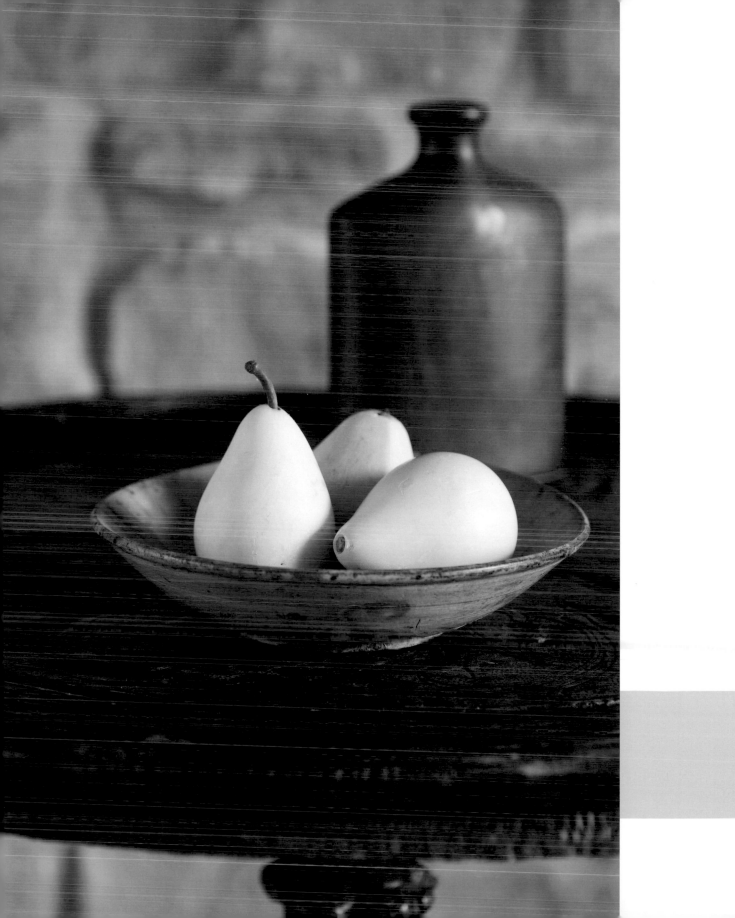

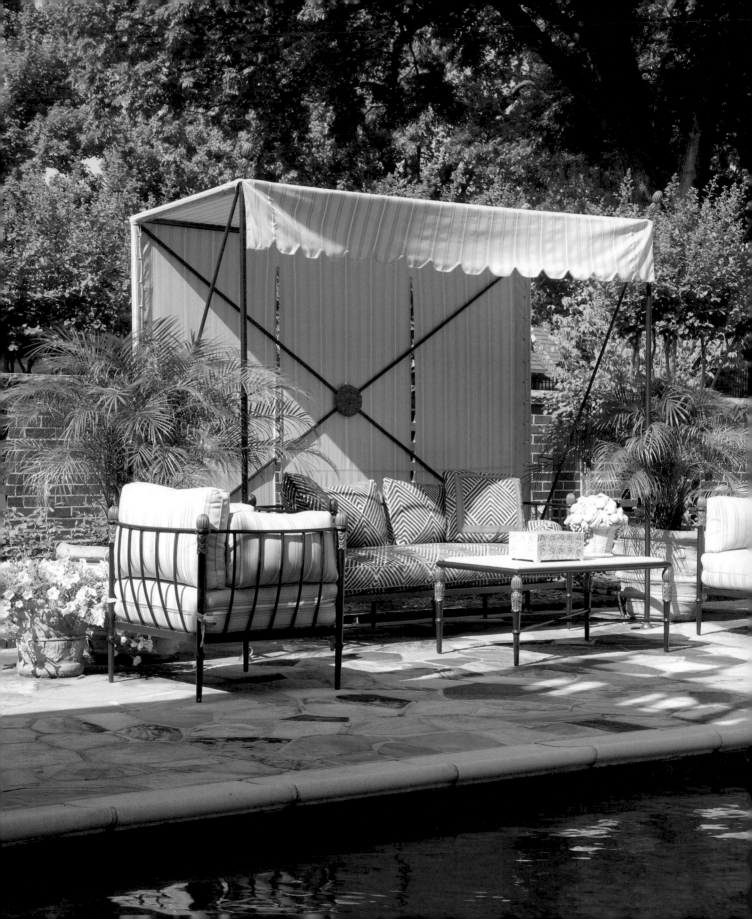

"Oh, Cabana Boy..."

Charles updates the classic cabana with simple lines and beautiful fabric, while touting his love for French country style . . . all the elegance without the pretense. One bleu choose olive is fine, really.

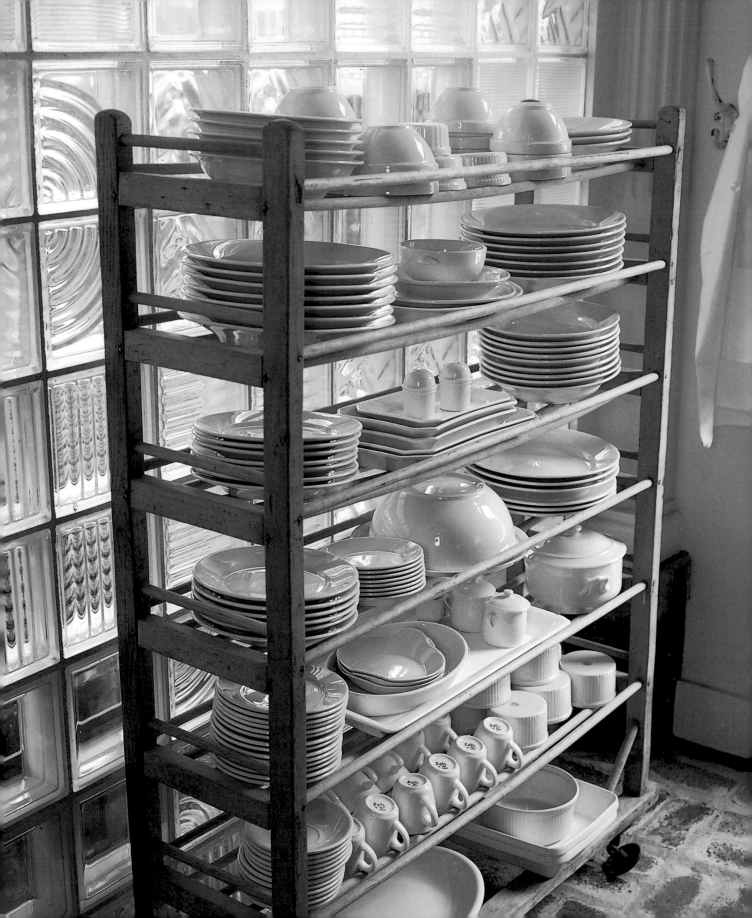

CHINA ★ SYNDROME

Caterer Page Martin's kitchen is a study in practicality, ingenuity, and good design. Page uses a vintage shoe-drying rack to house her all-white china, easily accessible and visually striking. Don't you love it when people find new ways to use old stuff?

WELL HUNG!

Andre and David use bed drapes, hung from the ceiling, to add warmth and drama. It's a traditional look, but done in a Delphina striped linen, it has a modern sensibility. And we love their custom-designed headboard! All that's missing is a truffle on the pillow.

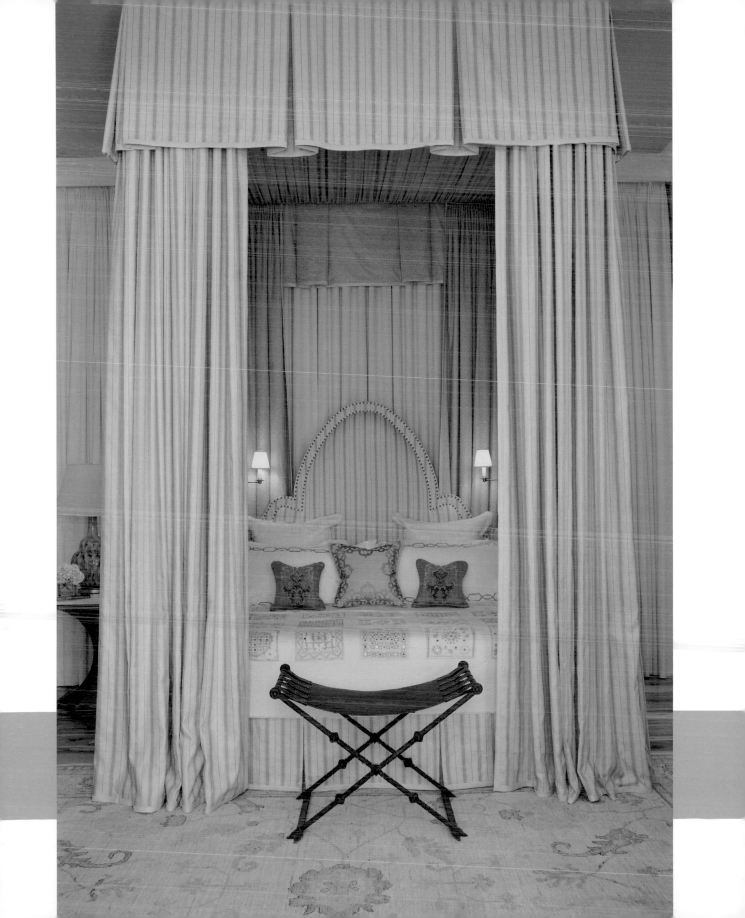

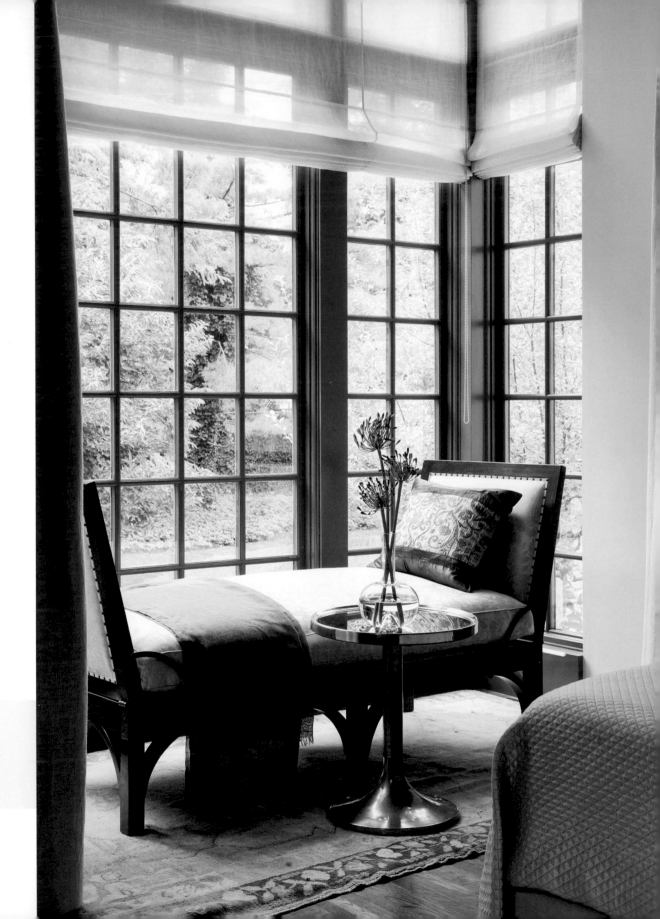

Anyone for **chaise** and crackers?

Denise takes advantage of the bay window in this master bedroom with a chaise longue - literally "long chair". It's the perfect spot to stretch out and enjoy a book, with a sexy little table to hold your drink. And with two backs on this antique chaise, why not invite a friend?

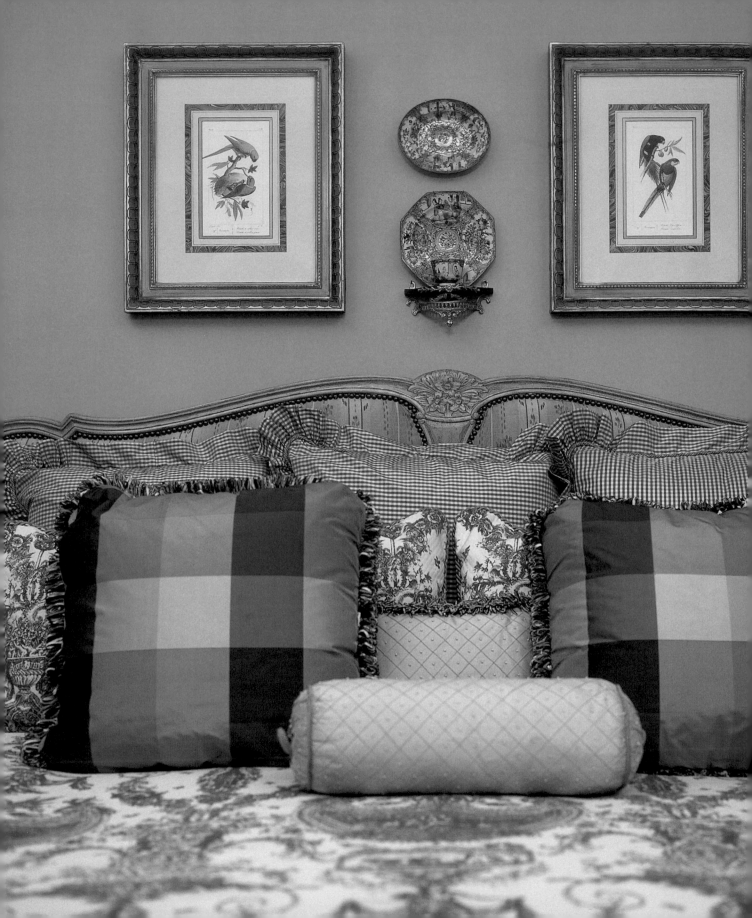

Pillow Talk

Charles dresses this bed with a combination of pattern and texture. Pairing toile with informal checks relaxes the space. Then he sets it all off with fringe, flange, buttons and trims. Bonne Nuit...

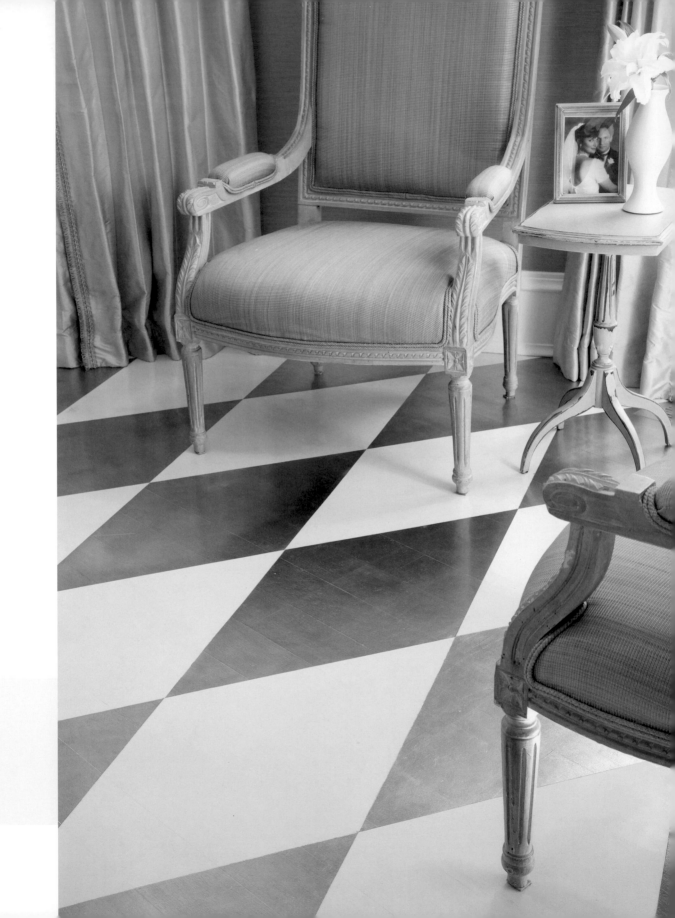

HARLEQUIN
Romance

Would you believe this is an office? Gail designed this home office space (there's a desk to the left) and then elevated it with a painted silver leaf floor. Add those luxurious draperies and walls covered in silk, and who wouldn't love going to work? Painted floors are a great way to personalize and add drama to your décor. The possibilities are endless.

Crystal Light

Great lighting can transform a space. In this hallway, Charles celebrates the light with a pair of candelabra and a brilliant blue bowl, positioned in front of French doors. A sunny day is a natural light show. Crowning this tableau is a fabulous hanging lantern. Enlightening!

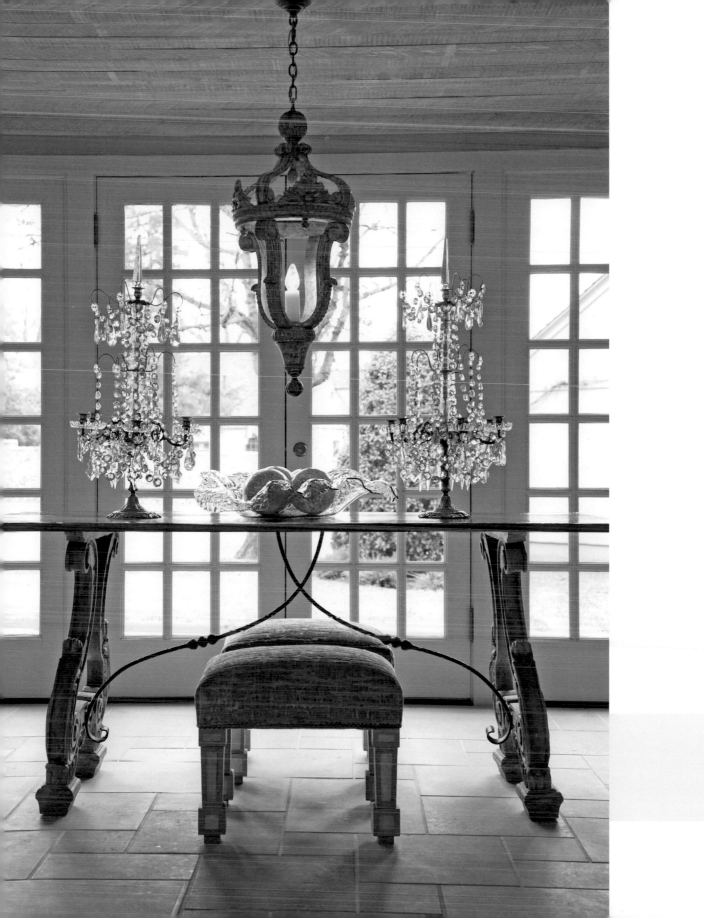

Tray Chic

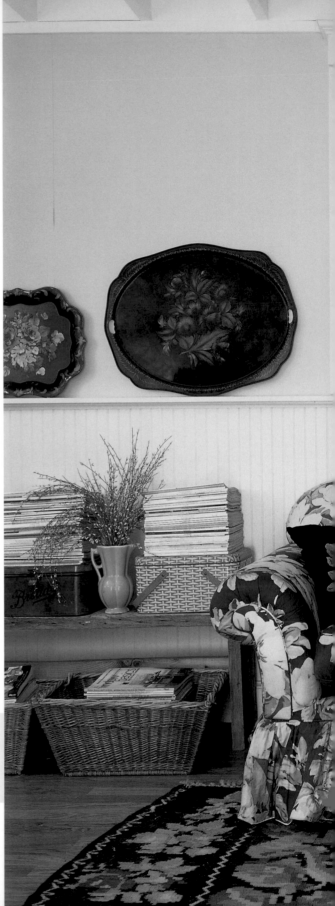

Jenifer uses a collection of vintage tole painted trays to create an unusual focal point. The florals add a playful element as the trays punctuate the wainscoting around the room.

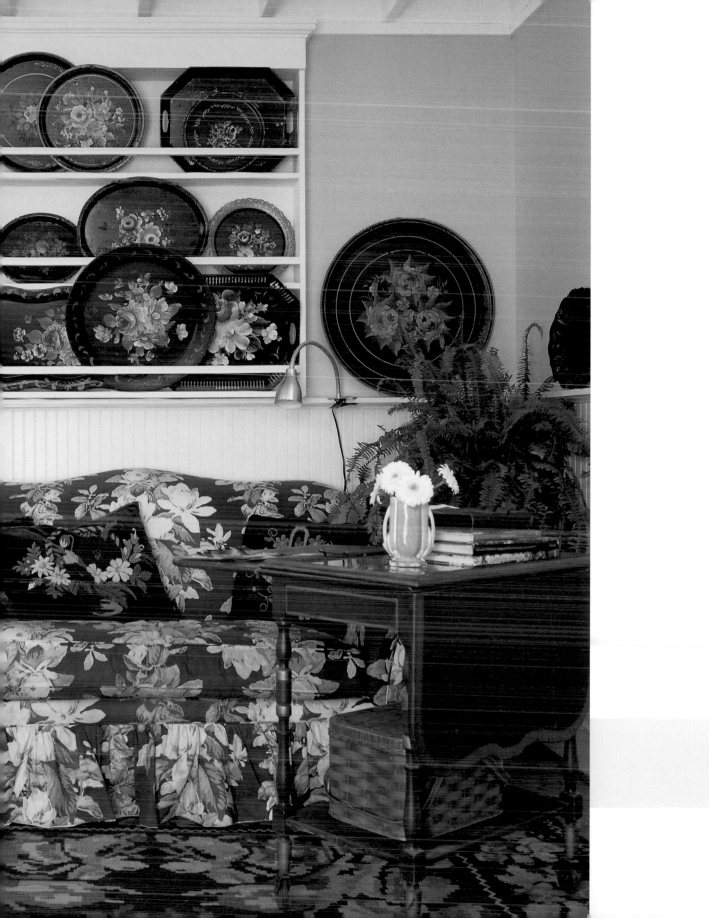

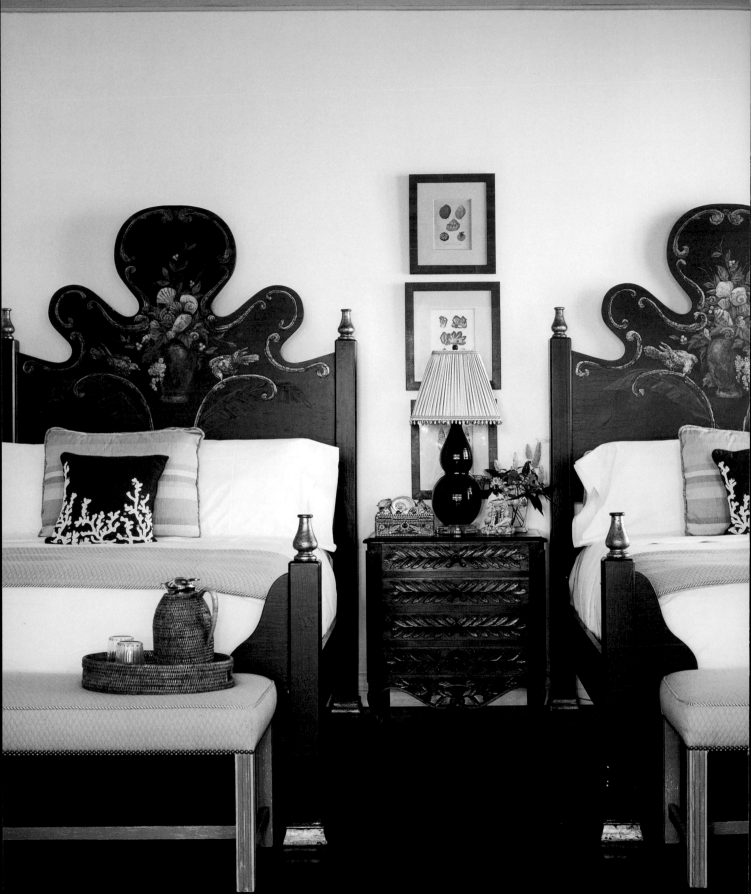

Double Header

In the style of Louis XV, Charles gives this guest bedroom 'wow' appeal with a pair of spectacular hand-painted twin beds. The symmetry gives the room a sense of calm. As for the gold detailing on the beds and benches, it's like that perfect piece of jewelry that pulls it all together.

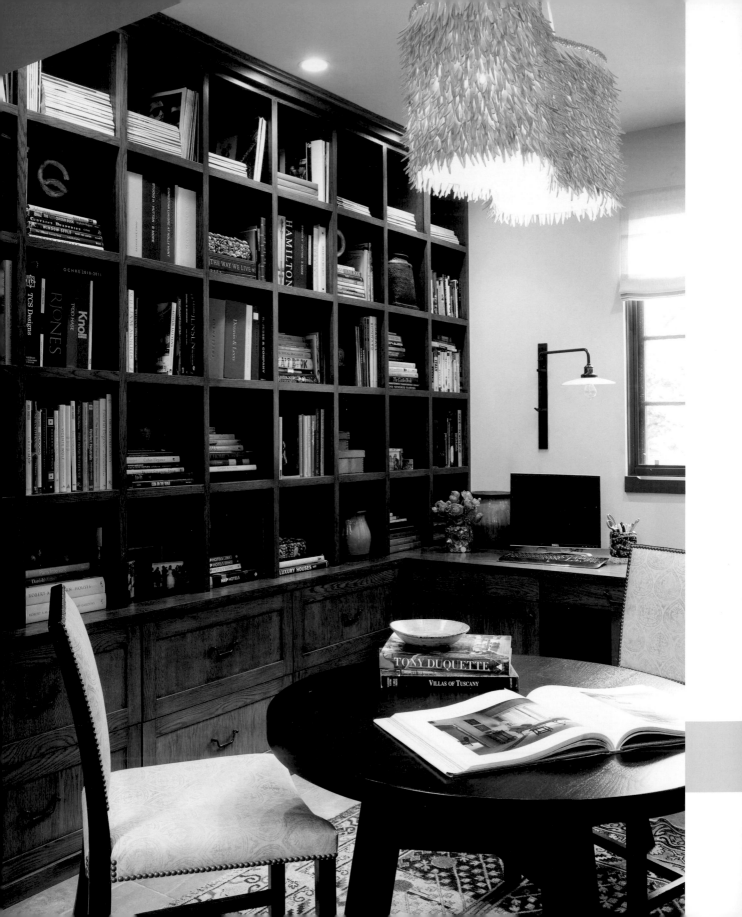

Boxed IN

Denise forgoes traditional bookshelves for a cubby approach – the same function with a graphic punch. This is thinking inside *and* outside the box.

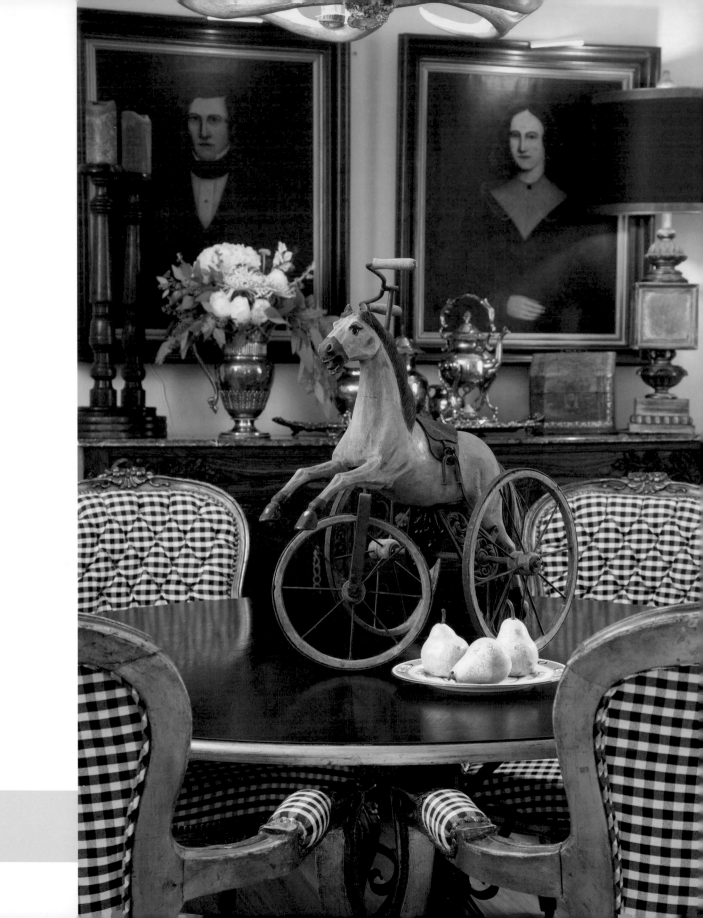

DRIVING Ms. Daisy

Jennifer Spak knows how to do traditional. But she livens it up with black gingham and an antique toy as a centerpiece. It's unexpected, over-scale fun. Race you for a mint julep?

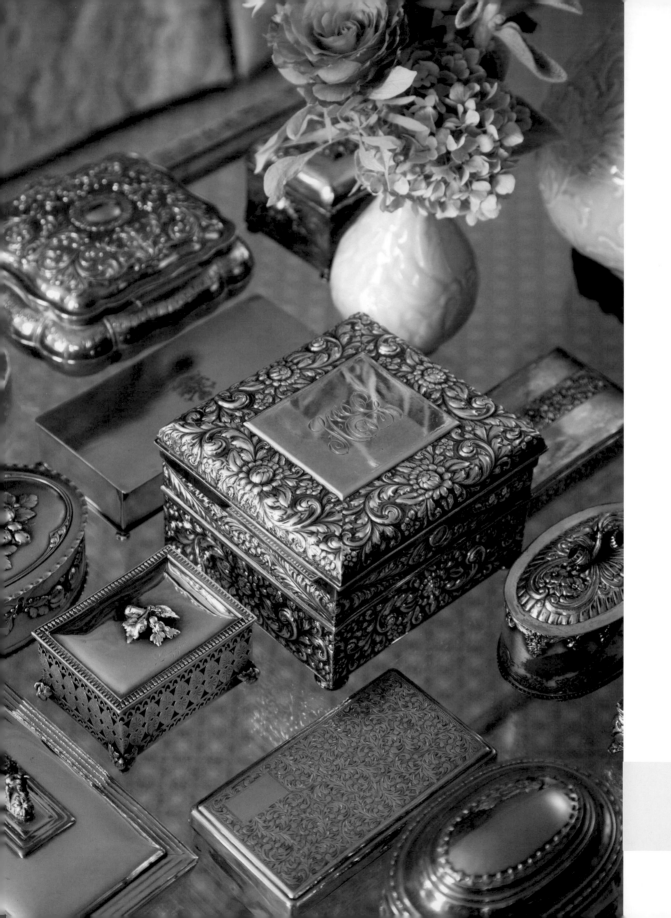

Silver Lining

Collections are a great way to make your home about you and what you love.
Charles highlights this homeowner's collection of silver boxes by massing them for impact.

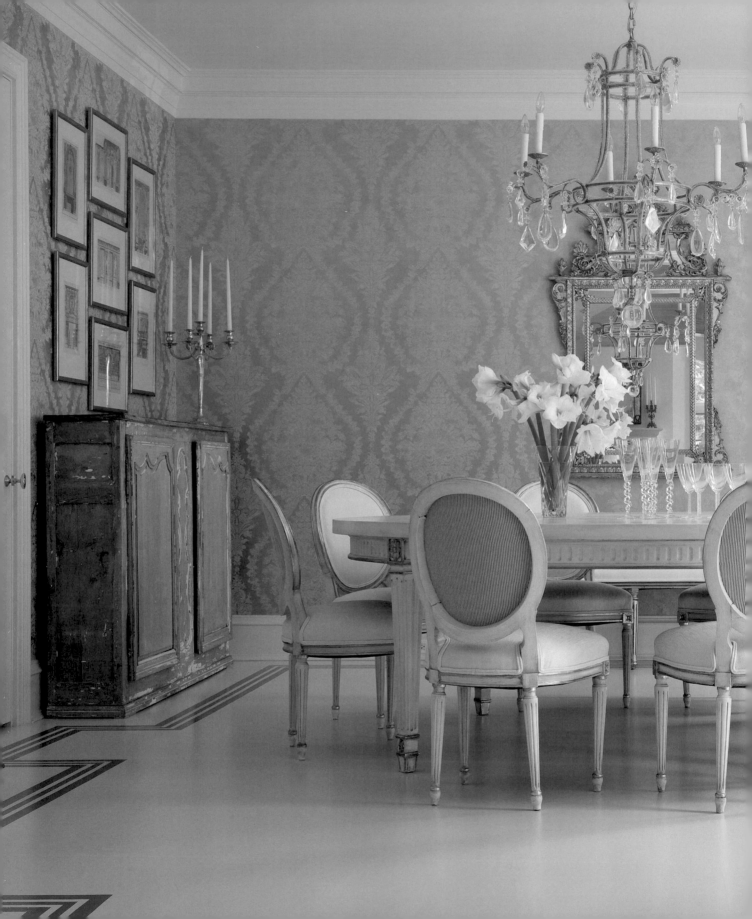

Nights at the Round Table

We love a round table in a square room, and for this dining room Gail highlights that geometry with a silver leaf perimeter. Balancing the glamour with a pair of crusty cabinets from Provence brings it all down a notch for comfort. Practical and pretty – always a winning combo.

Tie One On.

"The smallest detail can have an oversized impact," says Charles. Here a decorative tassel is the key to this Minton Spidell hand-painted chest.

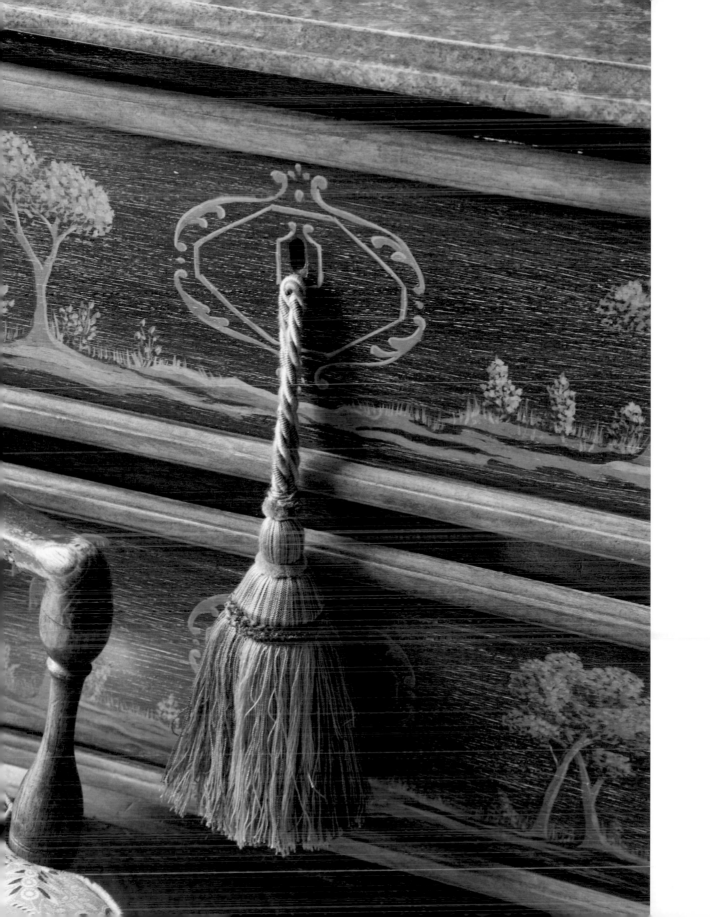

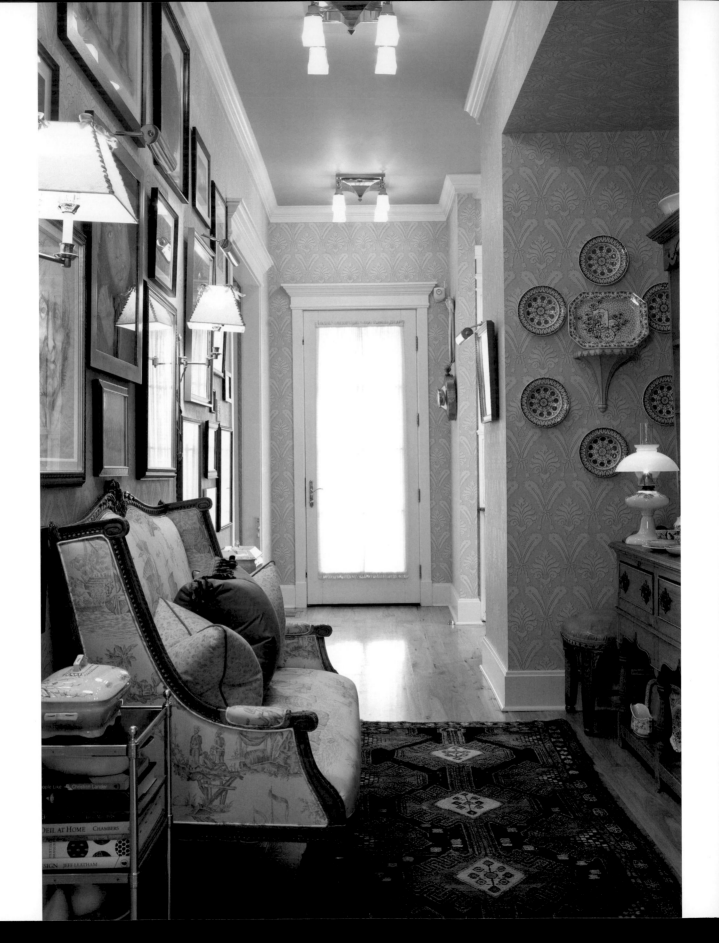

Hall Pass

hilary

Andre and David take advantage of every opportunity to create, like turning this rear entry hall into a gallery. With art and family photos, books, and a fabulous collection of transferware, the antique couch begs the question, "What's your hurry?" Look for hidden opportunities to display, to get comfortable, to enjoy your stuff.

OPEN
SEATING

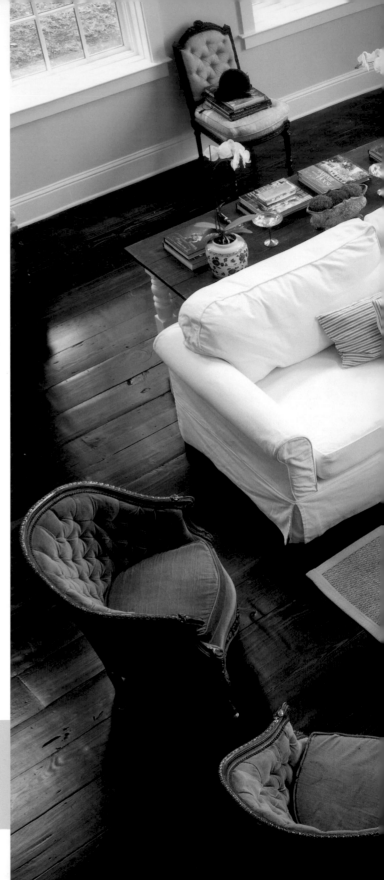

Annie Uechtritz mixes slip-covered sofas with antique chairs and an old pine table. Played against dark wood floors, the look is pure shabby chic. The floor plan is open and flexible – great for everyday living and entertaining. Pull up a chair!

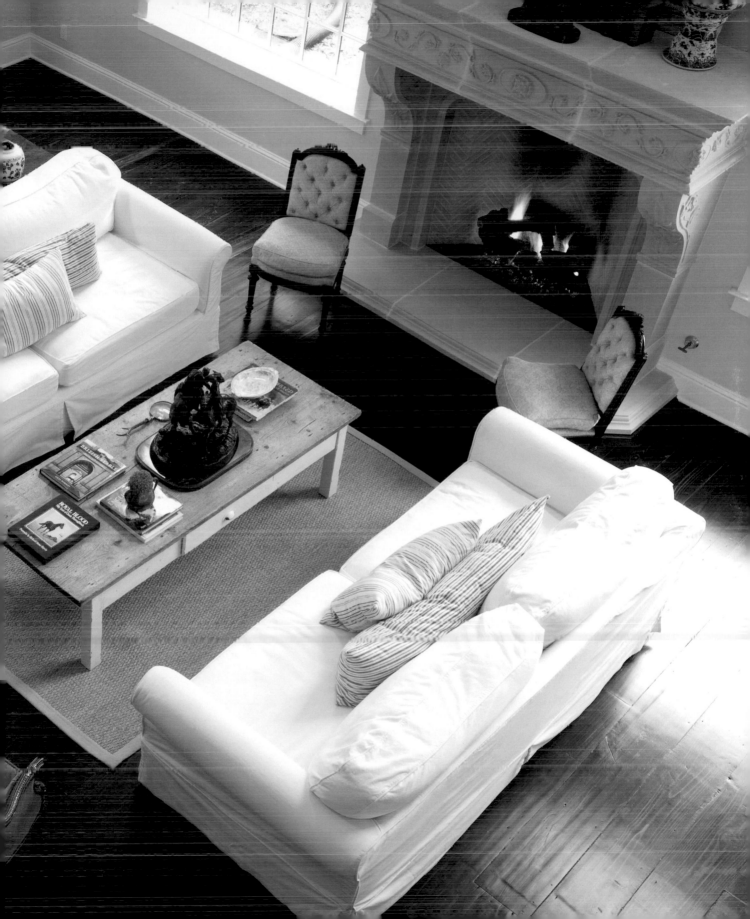

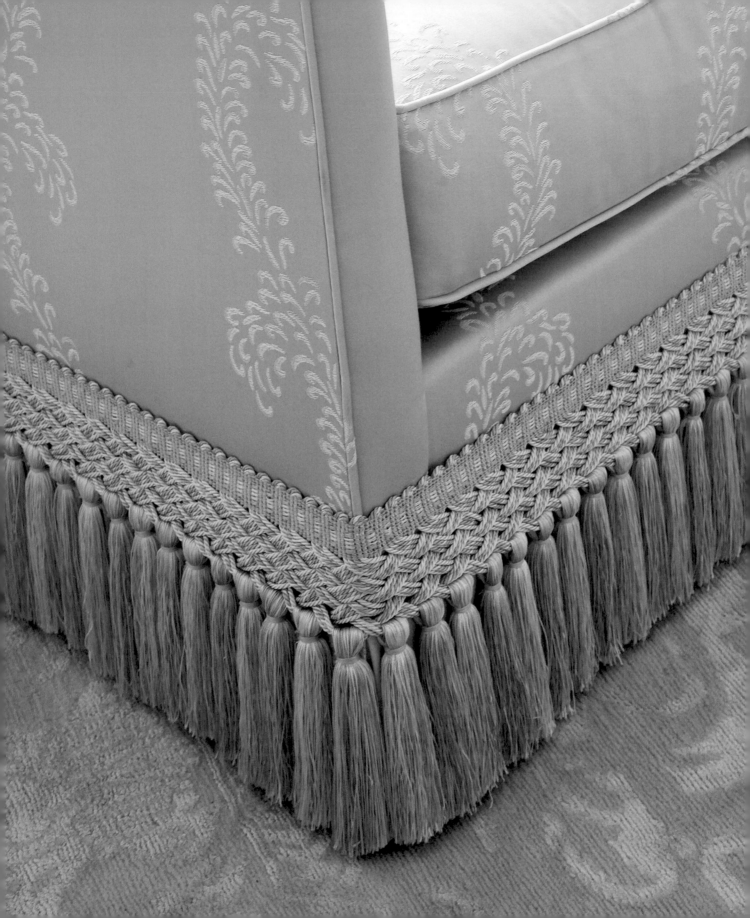

FRINGE BENEFITS

Gail finds a little detail can lend a lot of luxury. This silk bullion fringe adds texture and depth for understated elegance on a classic club chair. Carefully chosen details can take a space from pretty . . . to pretty spectacular.

Dog Gone It!

Andre and David have collected Airedales for years, both puppies and porcelain. Here they have combined their collection with vintage books, housed in an antique secretary. Their dog collection tends to move about the house, as does the art and some of the furnishings. Set your collections free! Objects in a new setting take on new life.

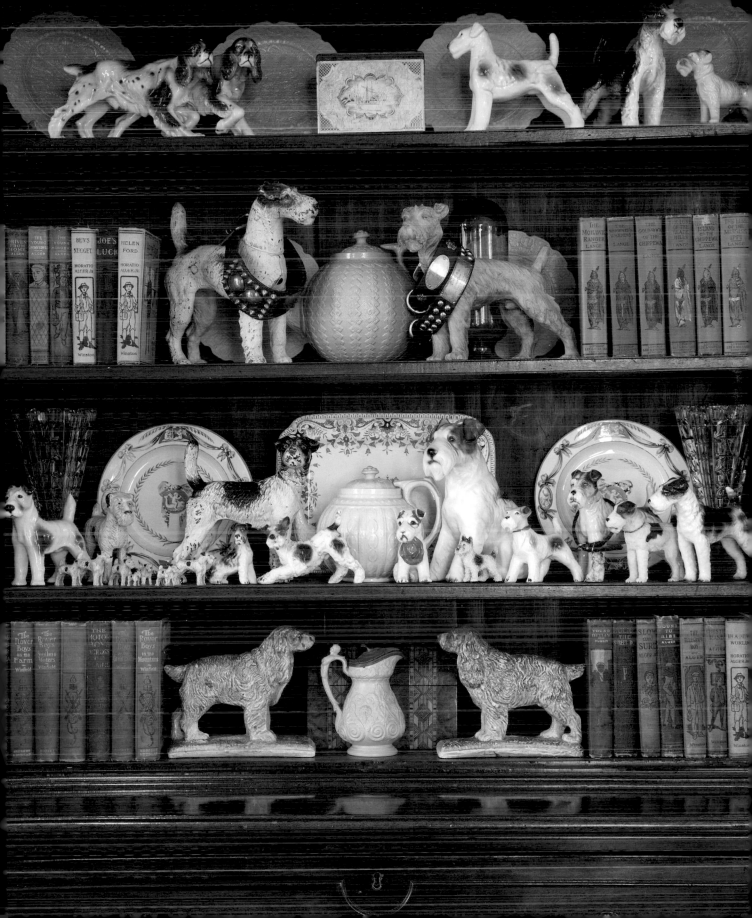

On a Roll

Twin bed frames on wheels give Page's guest room flexibility as well as a touch of industrial chic. In lieu of night tables, she opts for a wall-to-wall quarter-sawn oak shelf. The warm wood is a nice counterbalance to the sleek brushed-steel frames. Smart solutions for a limited space.

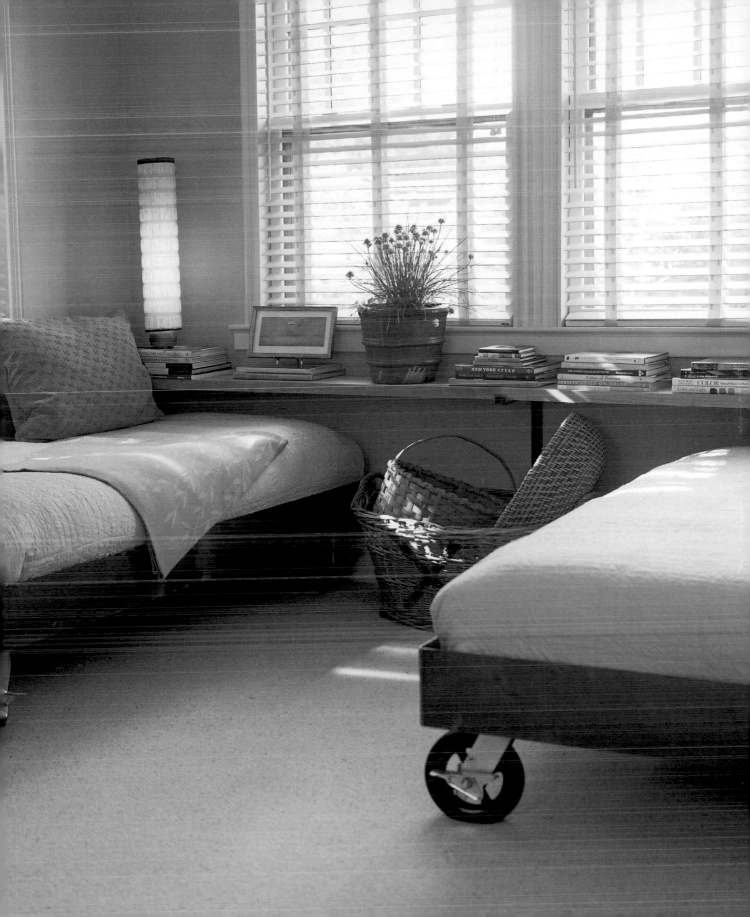

It's okay to be
shellfish!

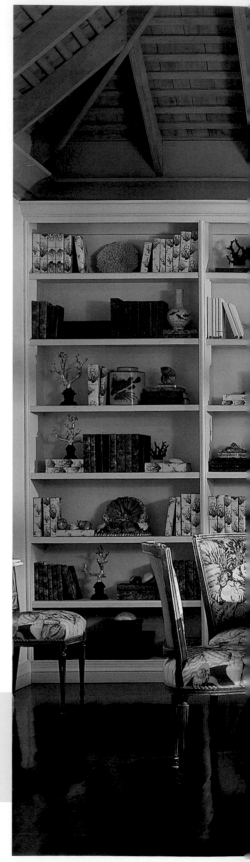

. . . and Charles uses the theme swimmingly in this island dining room. A classic bronze and crystal chandelier, dripping in seashells, provides a focal point for this aquatic mélange. With its muted coral palette, you can almost feel the sand between your toes.

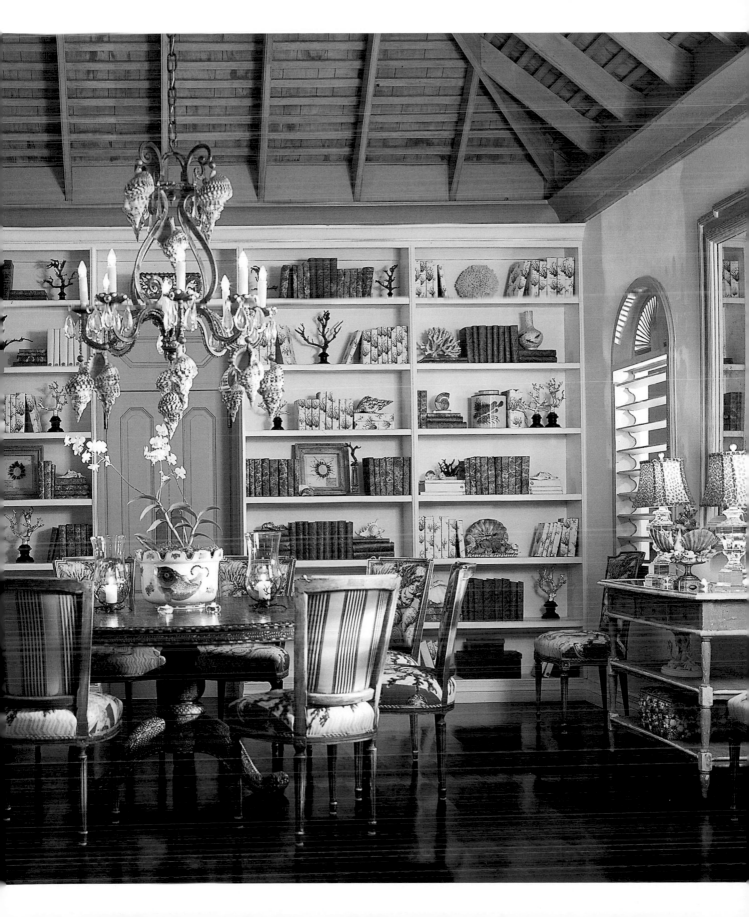

Whoopie Cushion

Andre and David always recommend 100% down cushions. True, they should be fluffed daily, but nothing else looks like down or comes close to the experience of sinking into pure feathered bliss. Sometimes you need to splurge because there's just no substitute for the real thing.

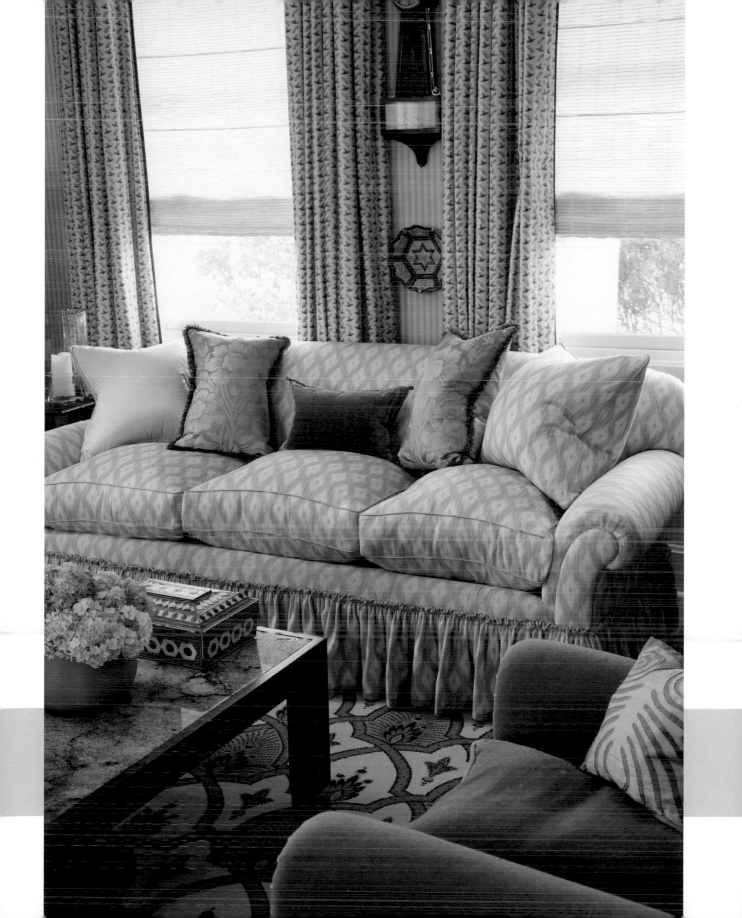

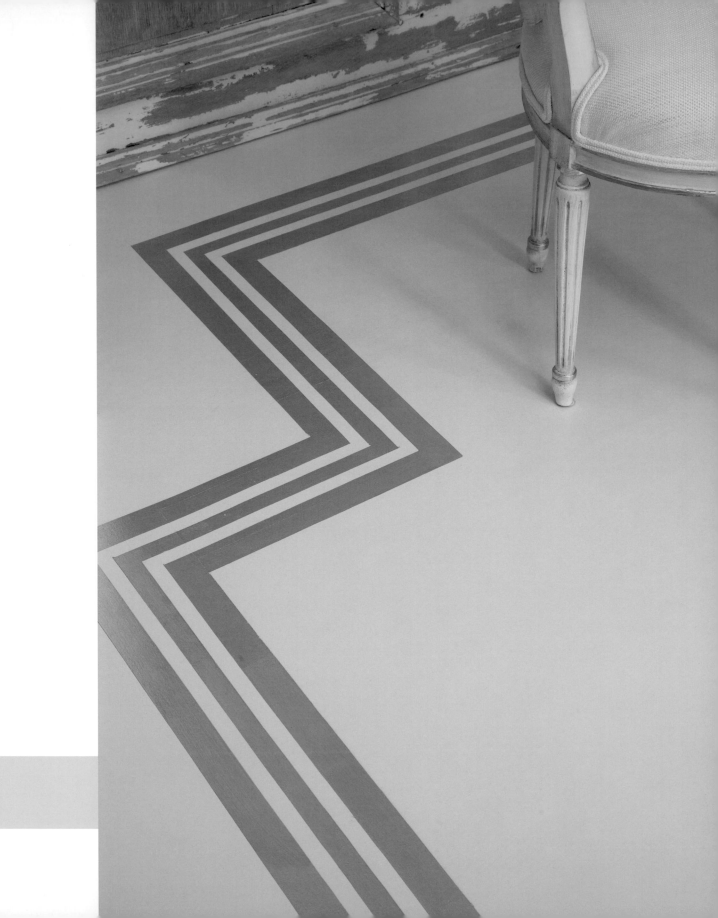

FLOORED

Gail painted the wood floor in this dining room and then added a silver and gold leaf perimeter to give it some glam. Champagne, anyone?

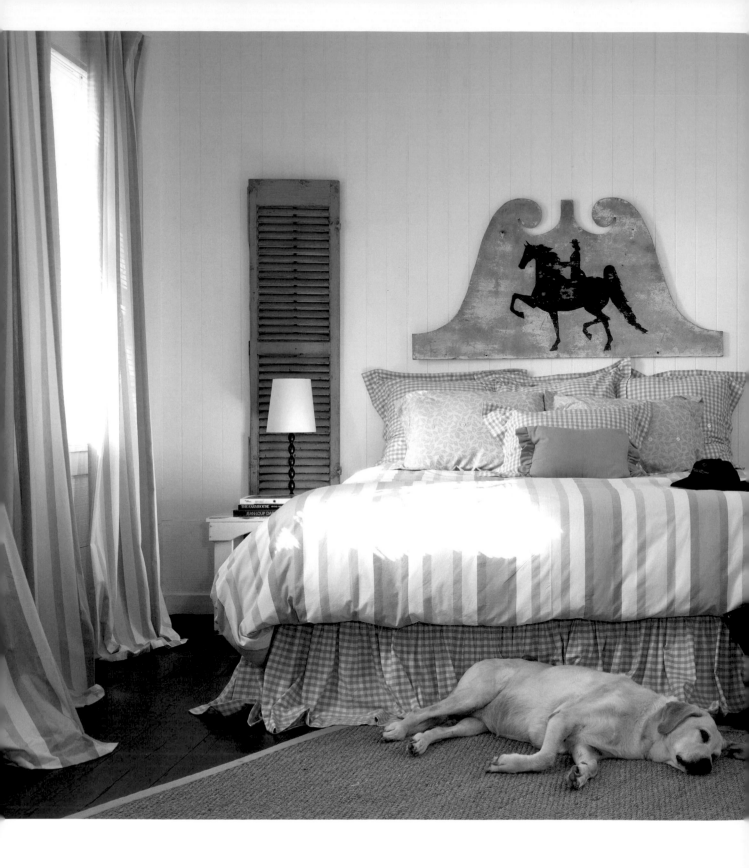

Horsing' Around

An old Saddlebred barn sign makes the perfect headboard in Jenifer's bedroom. The vintage shutters add balance, color, and texture. And any self-respecting country girl will love the checks with stripes. On the other hand, Jenifer's dog, Sister, is too tired to care.

Blue Plate *Special*

Jennifer Spak has a passion for blue. For this kitchen office she creates a wall display with English transferware, flow blue, and an old clock – on a blue wall. If it's not built-in, it's blue. Proving that getting the blues can be a good thing!

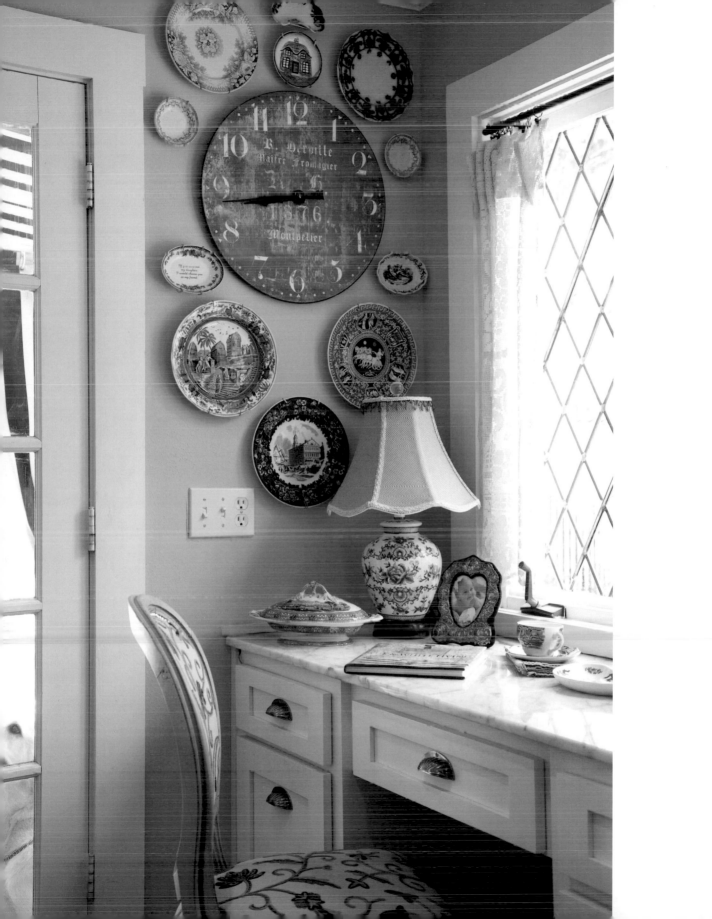

Roundabout

Just off the entry, this area is the hub of the house, and a tricky spot to decorate. Andre and David needed to keep the space navigable yet integrated into the rest of the décor. The solution? A skirted table, perfectly proportioned for the space, stacked with their favorite design books. Function first. Good design follows.

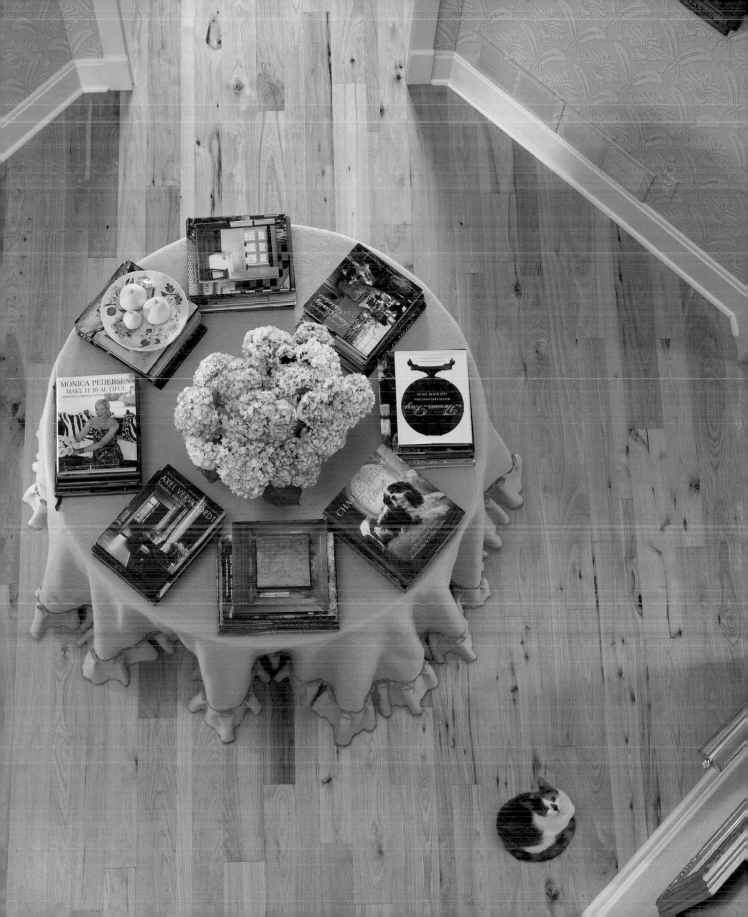

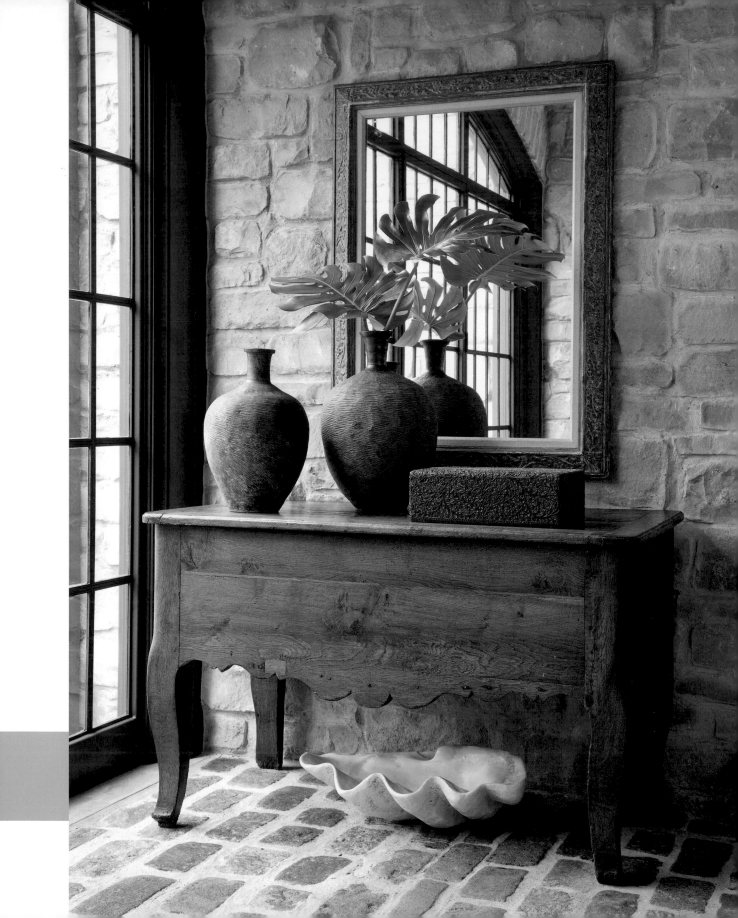

CHESTY

This entry is all about scale and texture. Denise uses a chunky antique Belgium chest to balance the heavy stone and ground the space. Two unglazed Chinese pots and a rare 'Monumental Clamshell' from the South China Sea reinforce the theme: Size *does* matter.

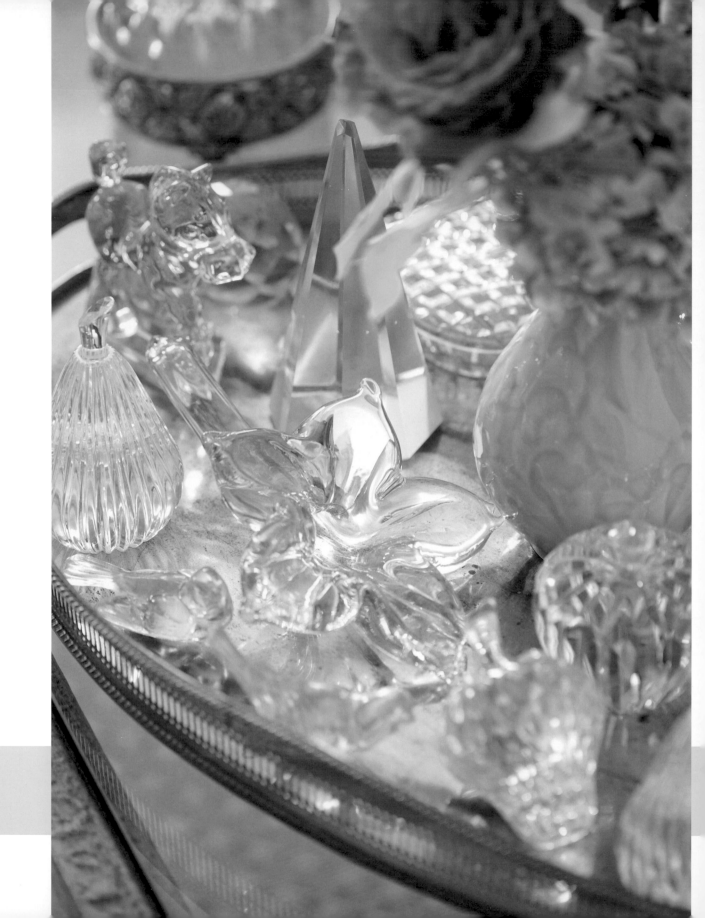

IT'S
CRYSTAL
CLEAR

Charles groups a crystal collection on an antique silver tray to create what he calls a tablescape. "It's an artistic composition of accessories," he says, "and an opportunity to include memories of friends and adventures to be enjoyed on a daily basis." It's all about living with what you love.

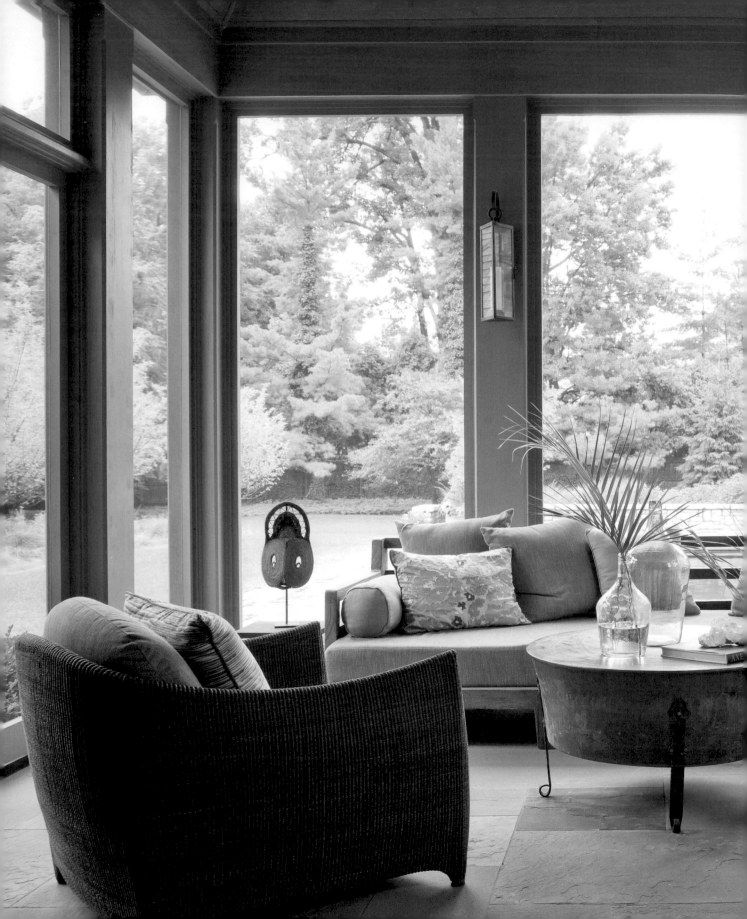

SCREENING

ROOM

Ahhhhhh the luxury of a screened porch: a summer retreat without mosquitoes! For this porch, Denise's earthy palette is a mix of texture. The wood, stone, rattan and weathered copper reinforce the feeling of being outside. All the benefits of the outdoors without discovering there's a bug in your drink.

Window
DISPLAY

Displayed alone, these three lithographs would be lost between the large leather chairs. Jenifer mounts them on an antique chapel window frame, making a creative statement, and giving them enough heft to balance the other pieces. Often the best design ideas come from solving problems.

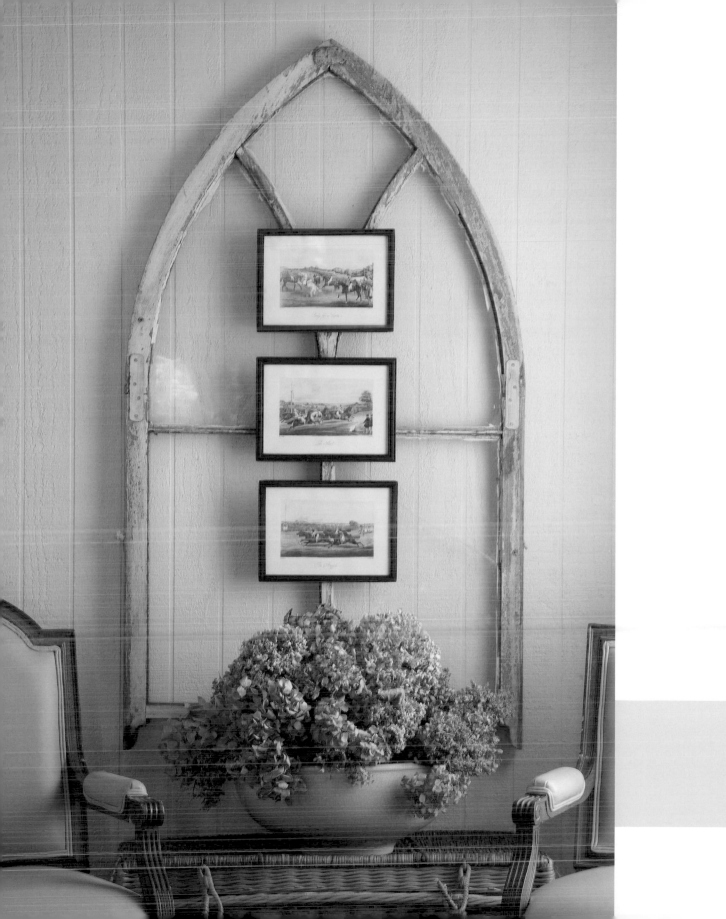

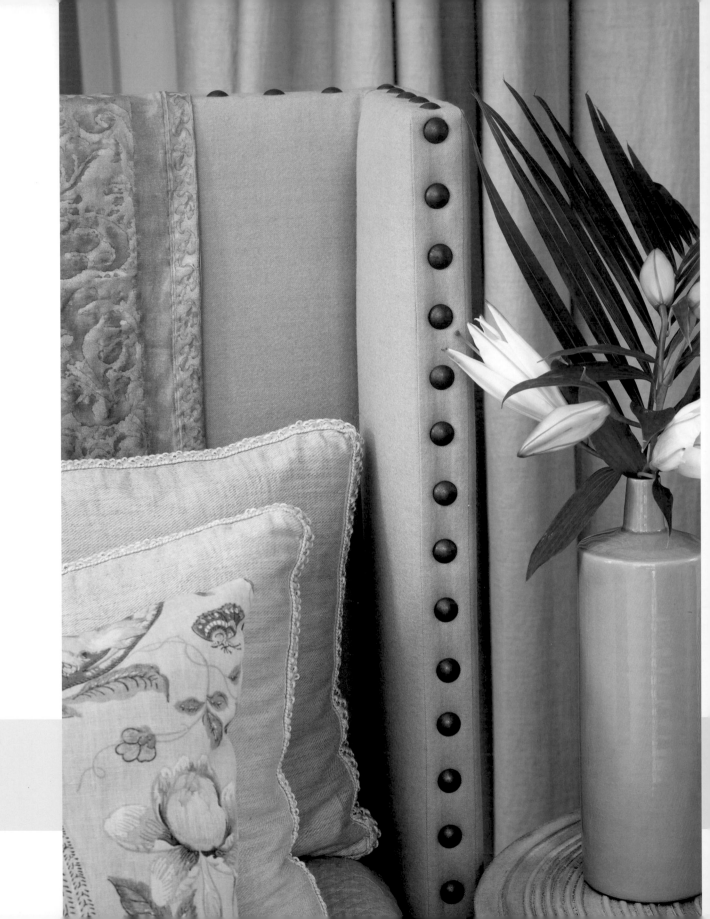

NAILED!

In this master bedroom, Denise adds a nailhead trim to the headboard on her custom 'wing bed'. The texture of hard metal plays against the elegant fine fabrics for a balancing act that's modern chic. Even the stone night table adds yet another layer of texture. It's a tactile experience all around.

Gh☺stbusters!

Nancy Ingram gives this dining room an unexpected modern twist, pairing Philippe Starck's Ghost Chair with a 19th century English farm table. Without taking up visual space, the Ghost Chair works almost anywhere – it's comfortable, practical, and so hip!

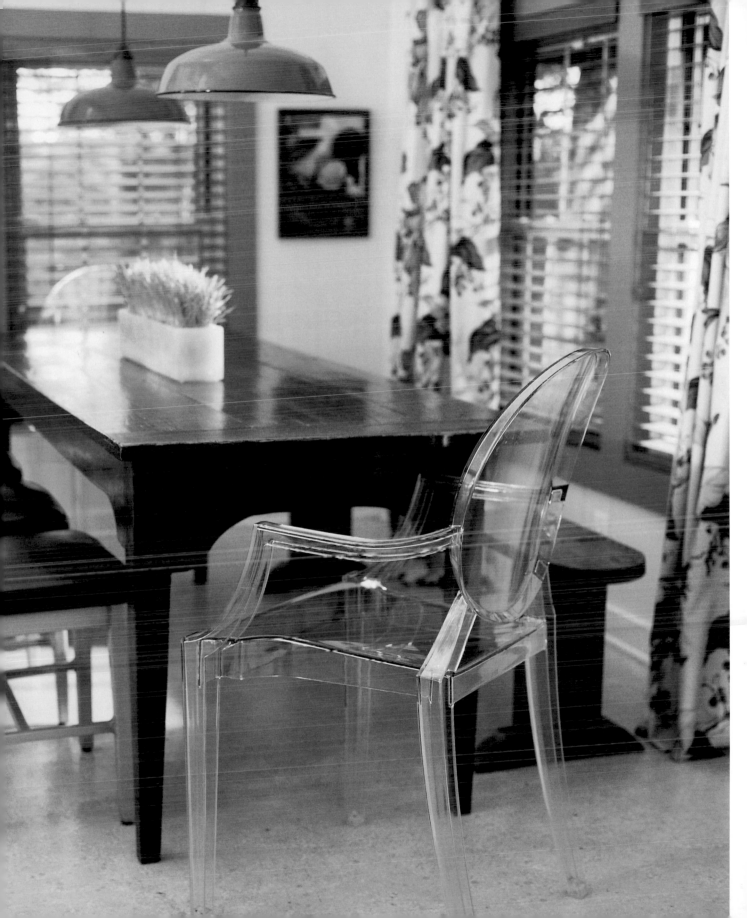

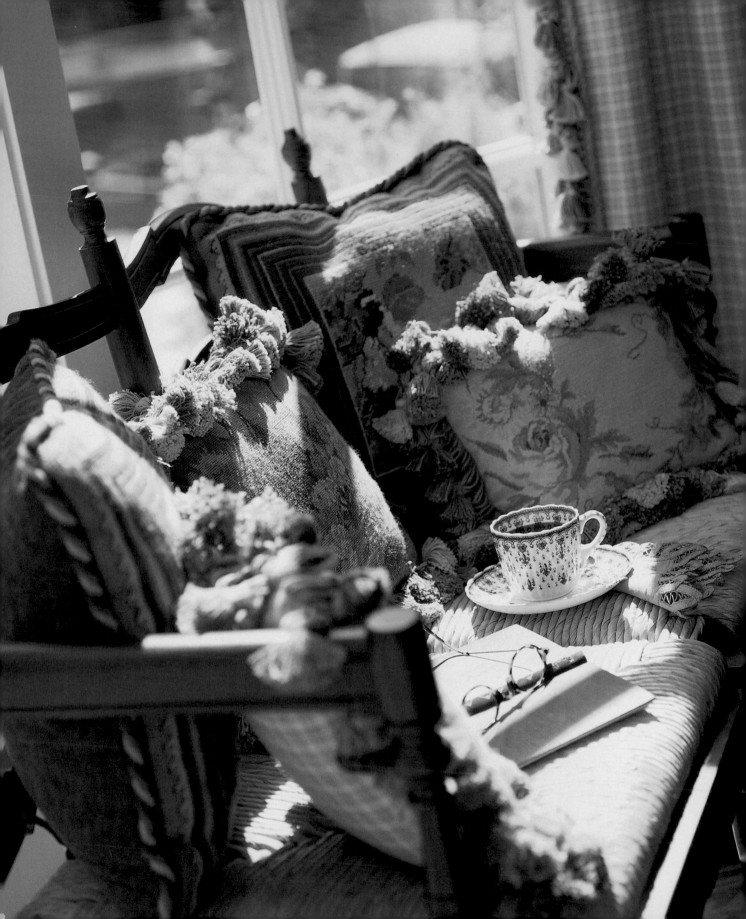

A True C Cup!

Take a moment for yourself. Charles accommodates with this antique woven bench softened with Aubusson pillows. A *tasse de café* amid the tassel trim. Voilá!

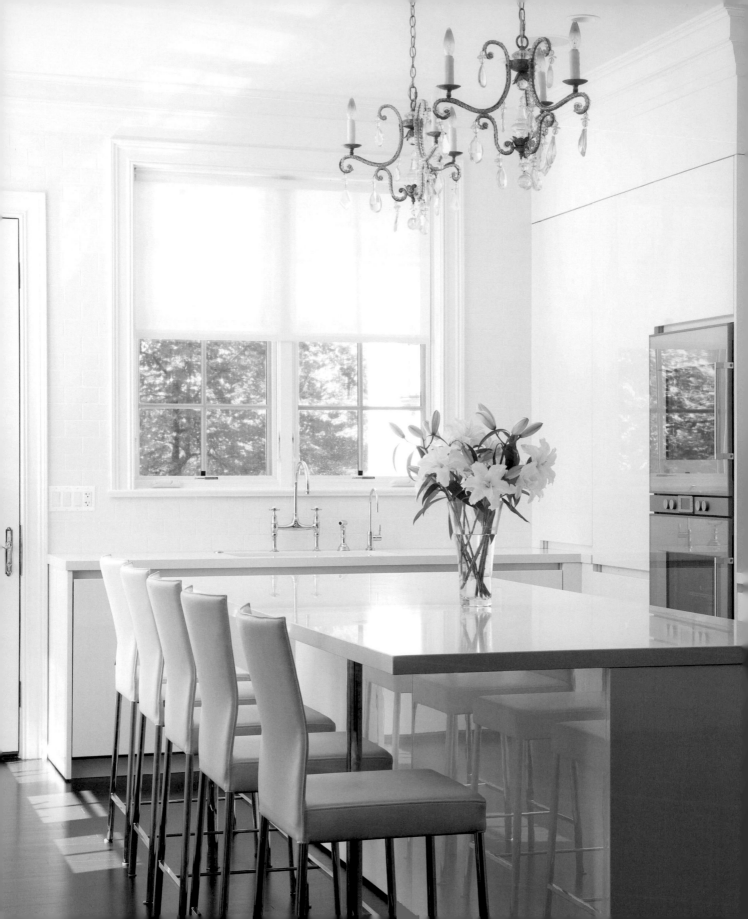

WAIT!
I think I see a crumb.

Looks like adults only, but don't be fooled by the minimal aesthetic and all white palette. Gail uses lacquered cabinets to hide little fingerprints in this family space. And we love a crystal chandelier in the kitchen. Even better? Two chandeliers!

TIME TRAVELLER

Charles goes Swedish with this unusual antique secretary and painted clock. The Swedish chairs, in the style of Louis XVI, get an update with checked fabric and a nailhead trim. Now throw in the acrylic bench – a modern classic – and this is an example of one of Charles' design tenets: "It's not the match. It's the mix".

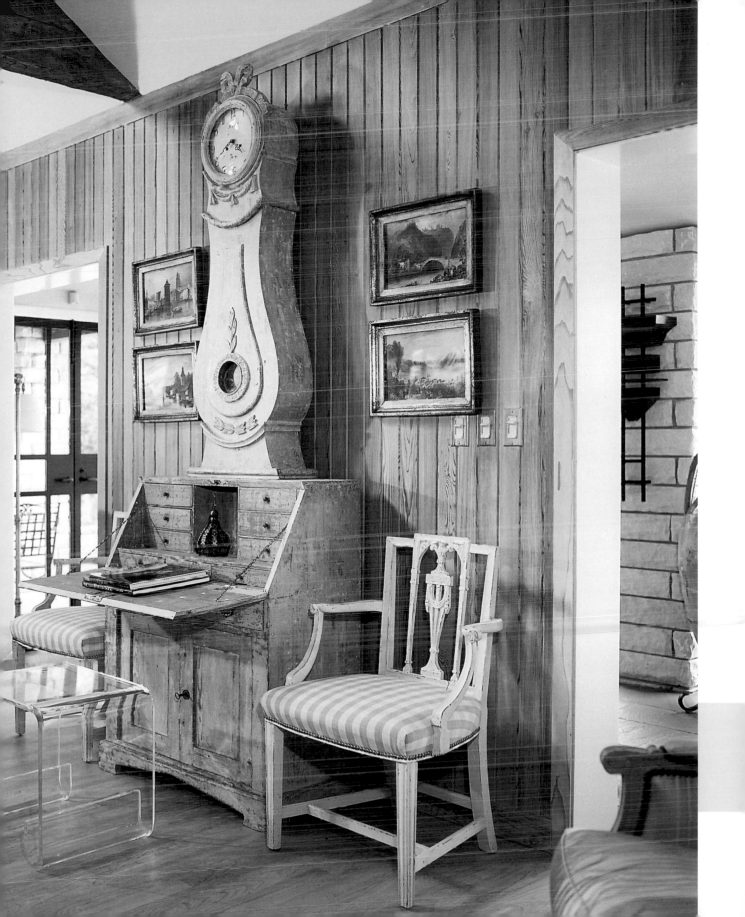

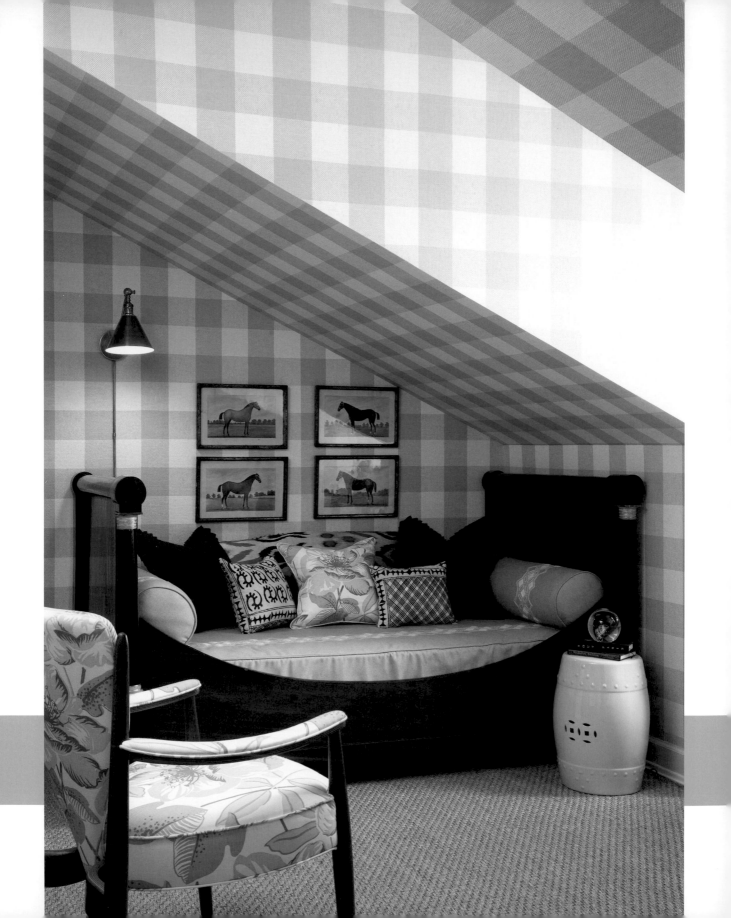

A Checkered Past!

Andre and David give a nod to the past in this dormer guest bedroom. With an antique daybed and a vintage chair, the sisal rug keeps the mood light. Then they wrap the room in unexpected checks. It's like a big hug.

SHELLACKED

Taking her cues from nature, Denise creates a vignette with these vintage shell boxes. They add texture and subtle nuances of color. Plus, it's a great place to hide the TV remote.

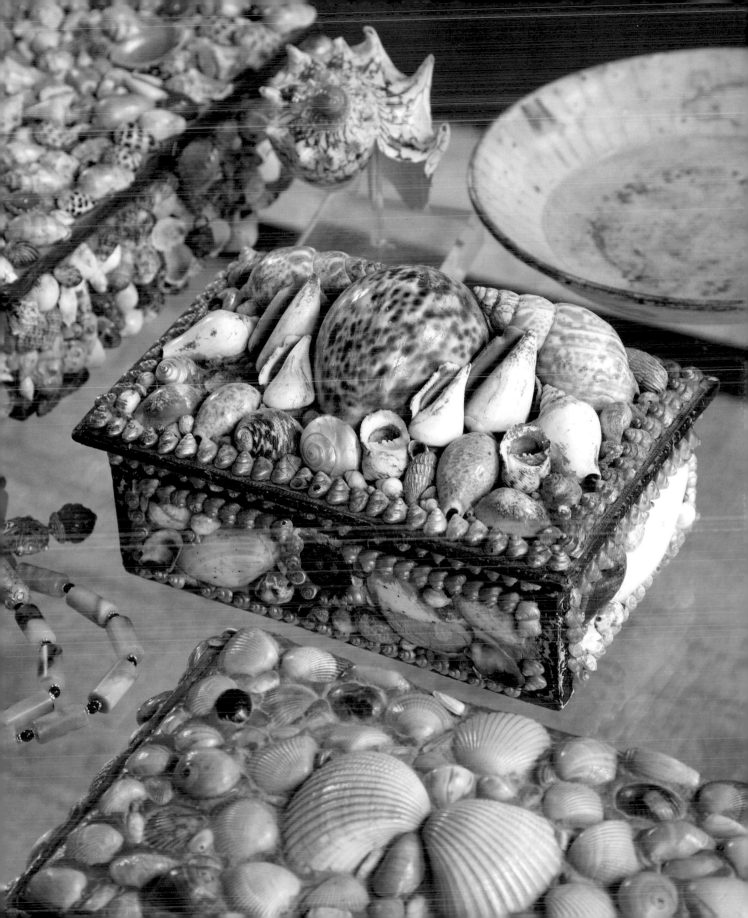

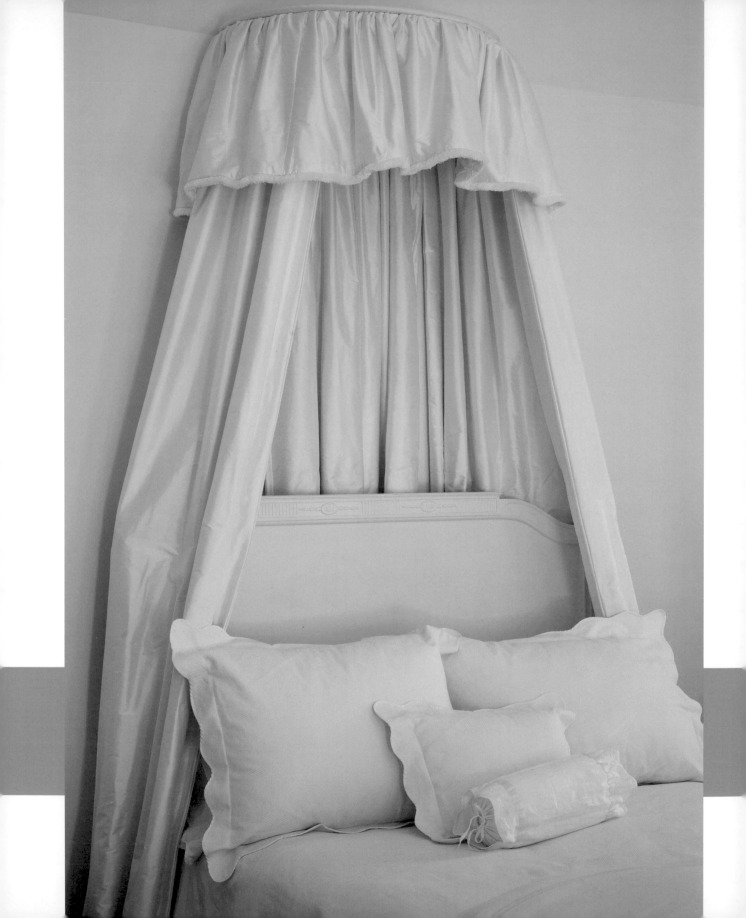

DRAMA *Queen*

Originally designed to protect the sleeper from falling debris in poorly constructed dwellings, bed canopies were also used for privacy and warmth. That was then. This is now. Gail draped 24 yards of luxurious silk to create an elegant focal point. Now this bed is fit for a queen.

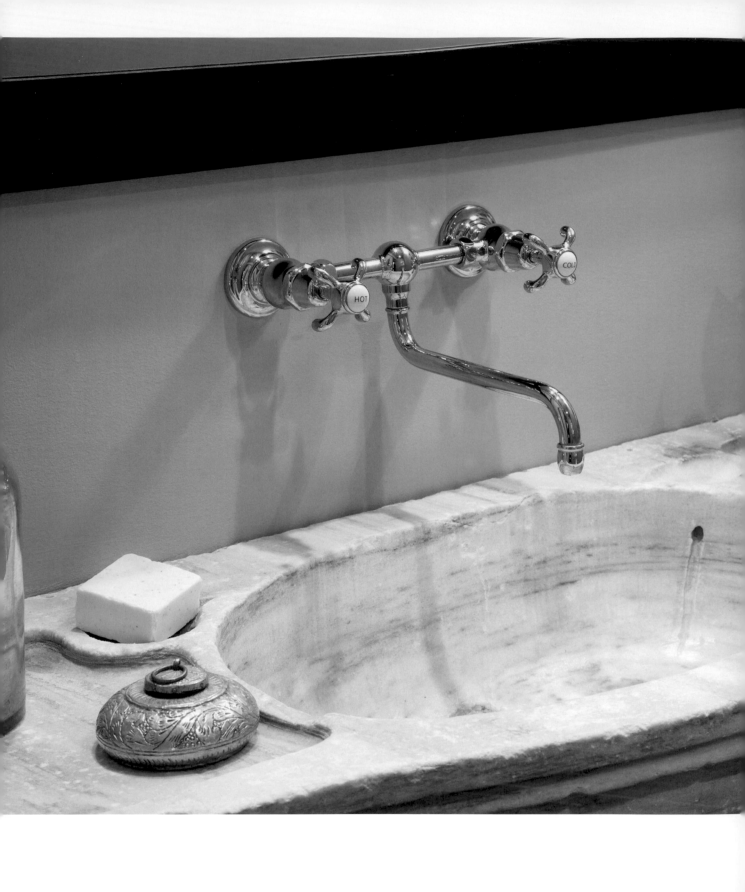

STONED!

Today's wall-mount fixtures allow for all kinds of creativity when it comes to sinks. Denise takes advantage with this antique marble sink from a Turkish bathhouse. Stretching wall-to-wall, it turns a small powder room into a big feature.

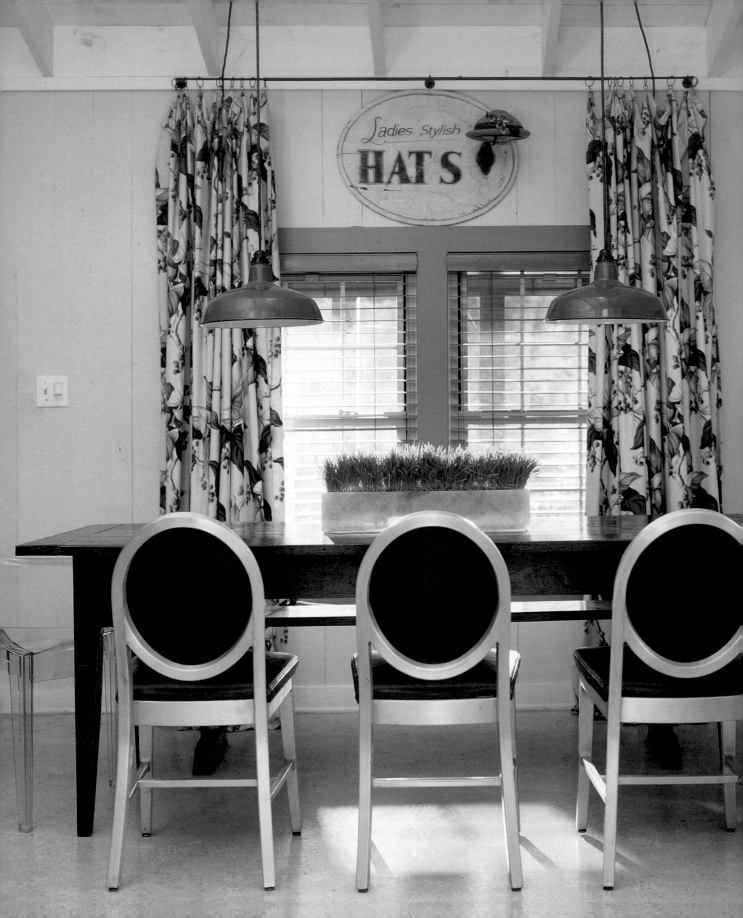

Chairiooo!

Nancy goes vintage with these flea market finds: 1930's aluminum chairs, 1940's bark cloth draperies, and 1950's industrial style hanging light fixtures. The grass centerpiece and her minimalist approach make it modern, while the red upholstery adds an energetic cherry punch.

The BEAT OF A DIFFERENT DRUMMER

Denise uses a Moroccan drum as a coffee table for this kitchen seating area. The copper drum reflects the warmth of the fire, and echoes the shape of the chandelier. Natural elements create the perfect spot for a cup of fair trade coffee.

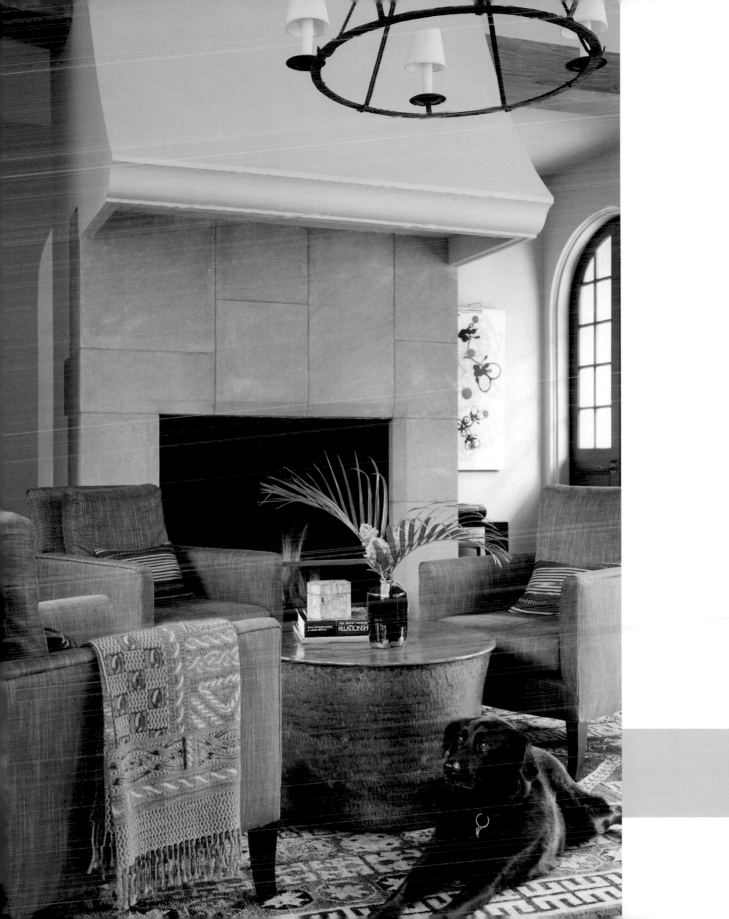

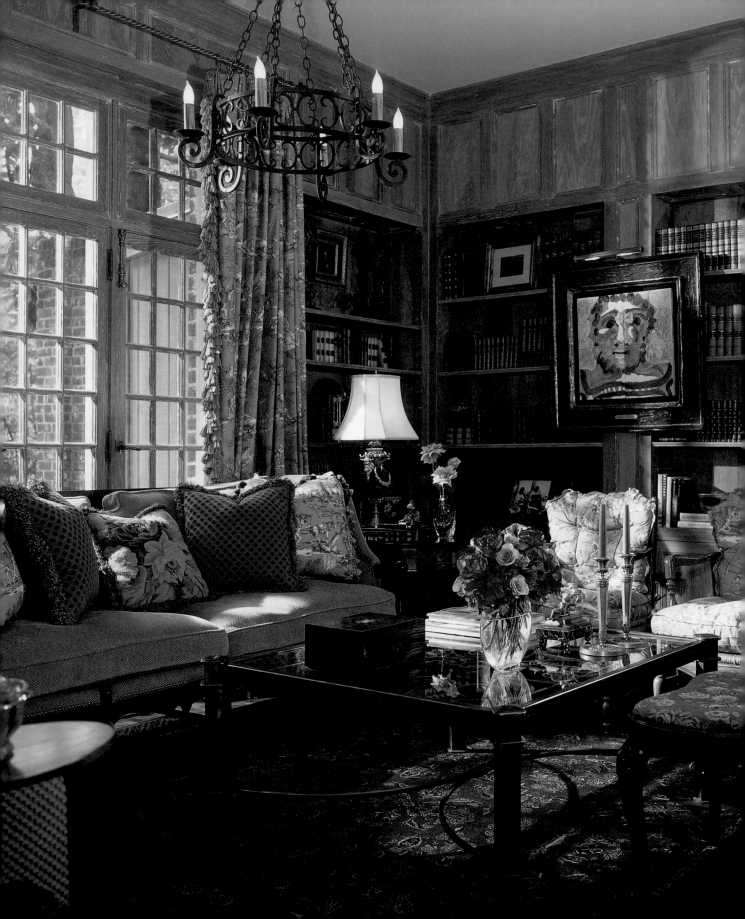

Pretty in PINK

Charles complements this paneled library with shades of pink. From the toile draperies, to the mix of pillows, to that fabulous antique Oriental rug, the room is bathed in a rosy glow. Pretty is always in style.

YOU'RE SO VANE

The scale of this vintage weather vane is perfect for Jenifer's 10-foot pine table. The column in the background is also an architectural salvage piece. When you're looking for that special something . . . look beyond the mall.

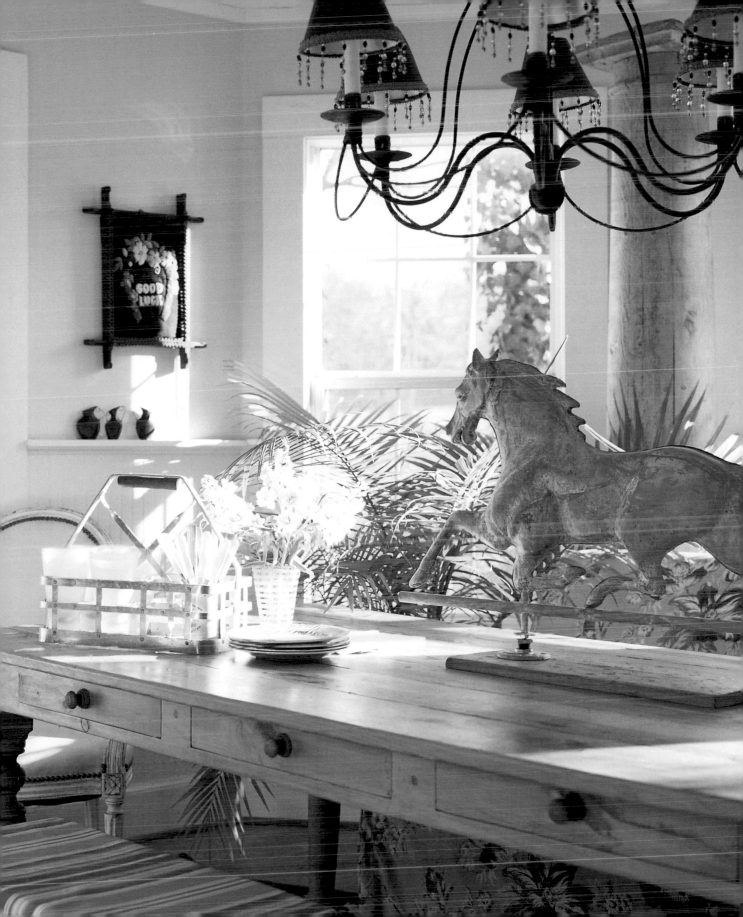

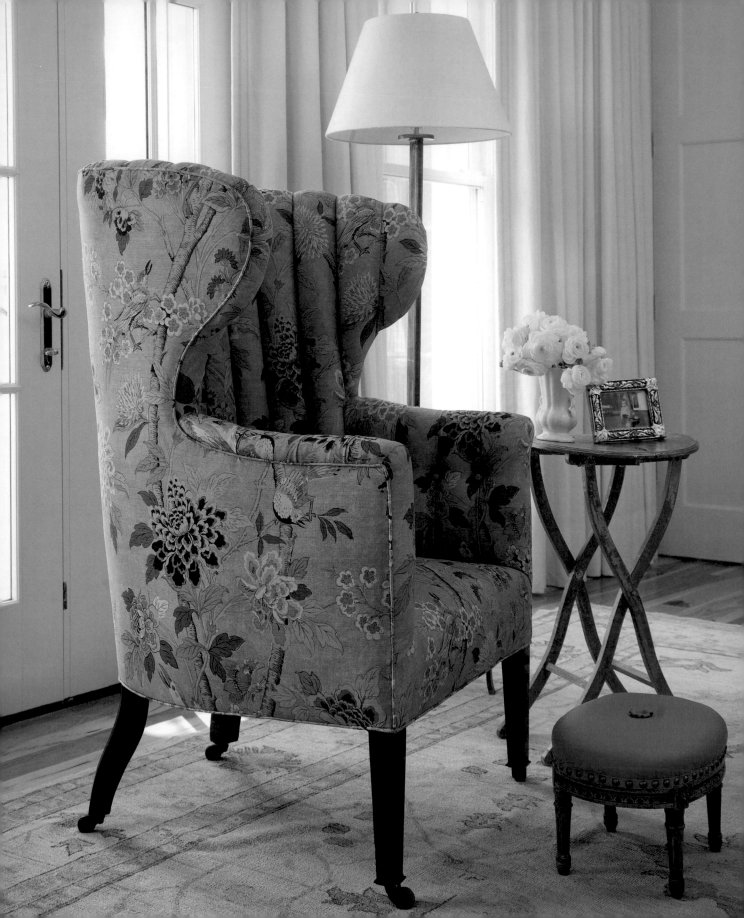

SOMETIMES YOU JUST HAVE TO *Wing* IT

Andre and David upholstered this 19th century English wing chair in 'Song Bird' linen from Bennison Fabrics. The exaggerated silhouette done in a fresh fabric gives this old classic a modern feel. And we love the bird reference on a wing chair!

Cabin Fever

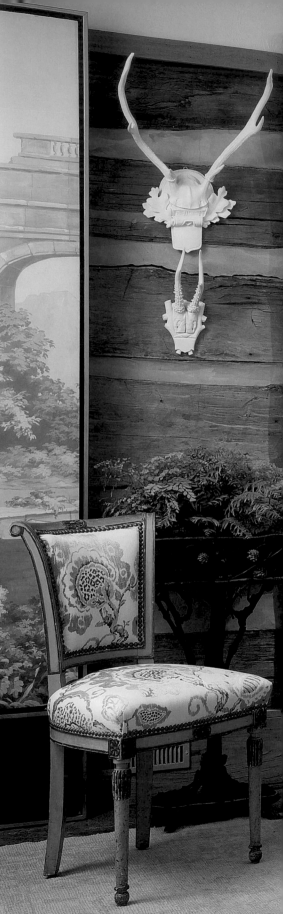

Charles takes cabin living to a fever pitch. He pairs elegant French country with chink and log construction, honoring the natural palette. The large wall hangings are actually antique French wallpaper, framed as artwork. Don't be afraid to go against the grain!

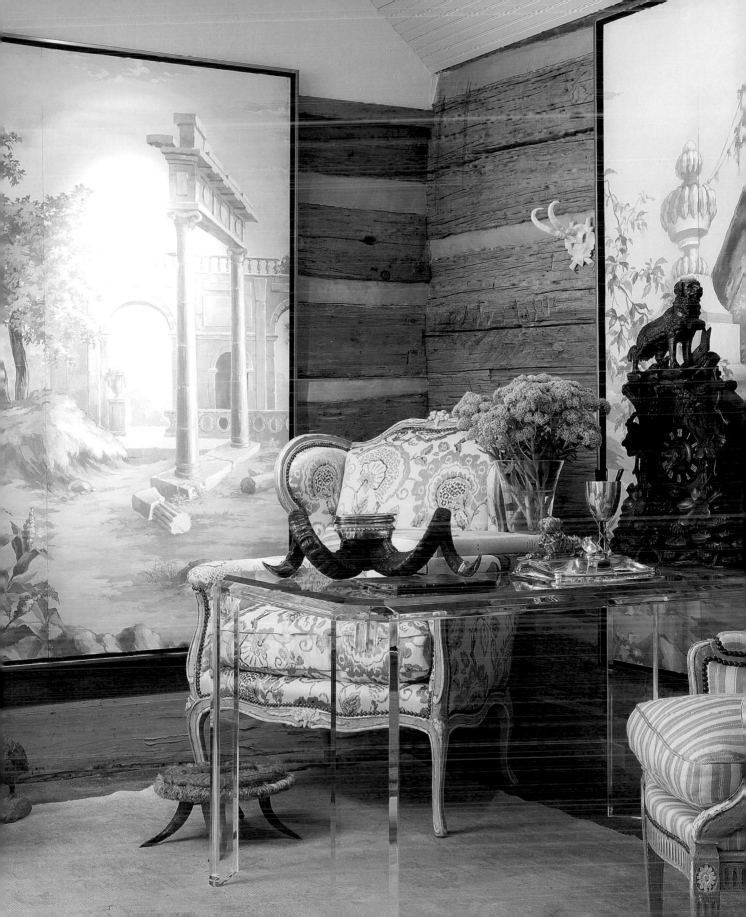

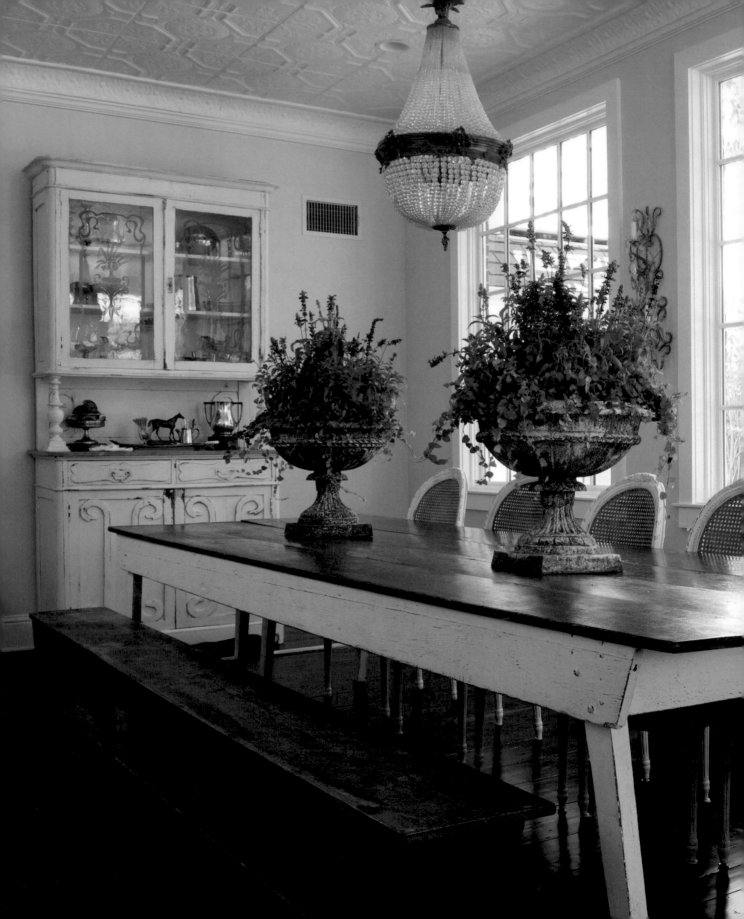

Benched

Annie reclaims two ten-foot vintage tables from a French boy's school, then adds an old country bench opposite a set of French side chairs. Split 'em up or keep 'em together - we love the flexibility of this space. It works whether you're serving soufflé or PB&J.

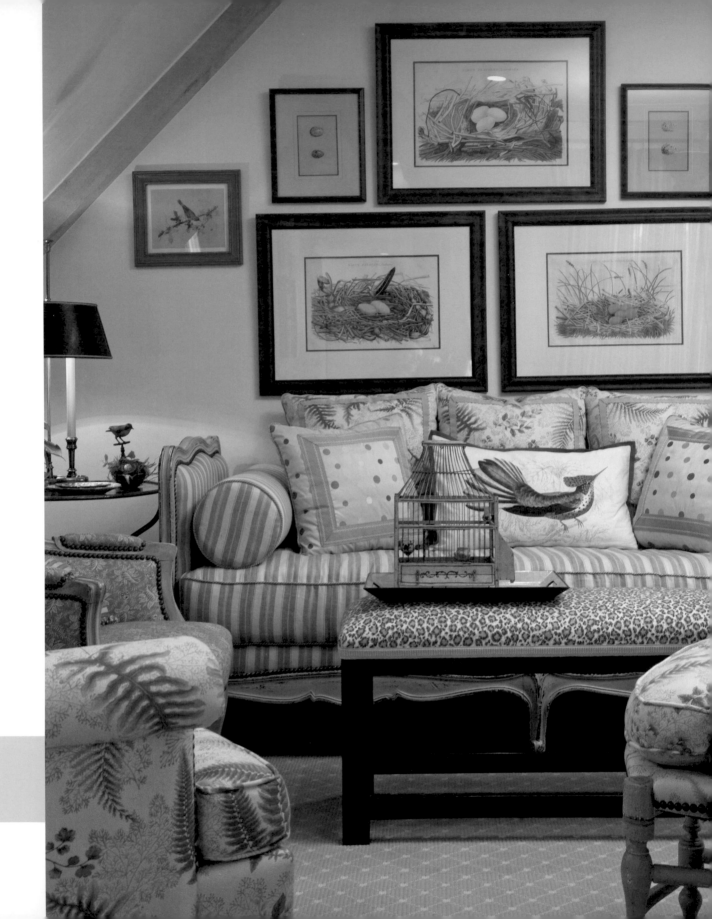

For The Birds

Charles transforms this landing into a cozy nook with a bird-inspired theme. The antique avian prints set the stage, while bird accessories and a botanical print fabric reinforce the motif. Talk about feathering your nest!

Wild
THING

Denise hangs a Laurie Hogan painting* over a classic 18th century Italian desk. A quiet corner is transformed by the intensity of the art. And check out Denise's custom bench, in an animal print. Of course.

* Hogan used her own dog to portray Daphne, a deity from Greek mythology.

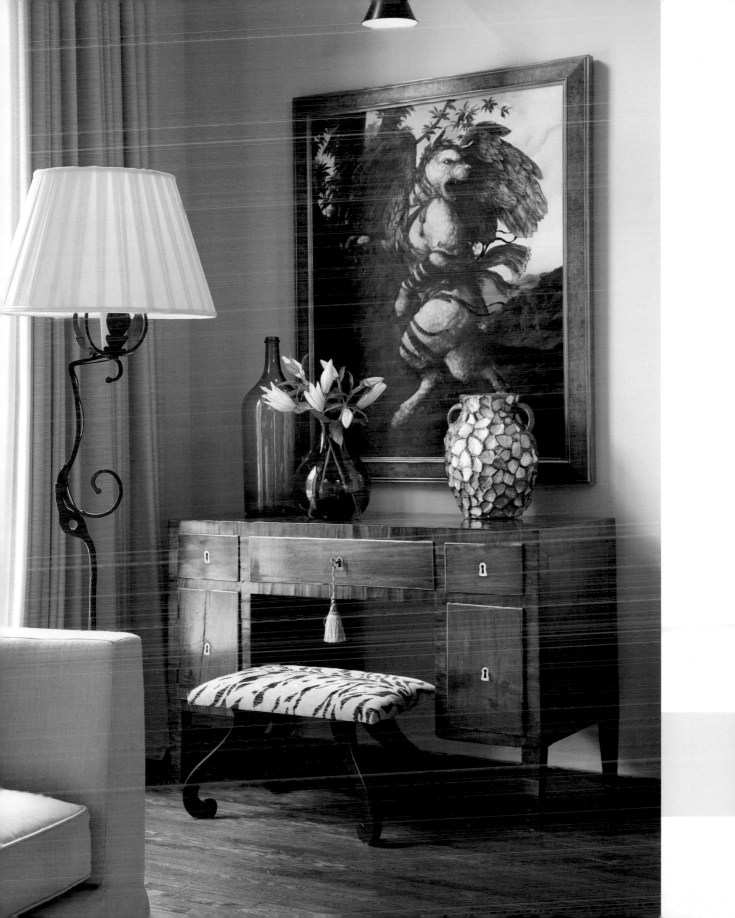

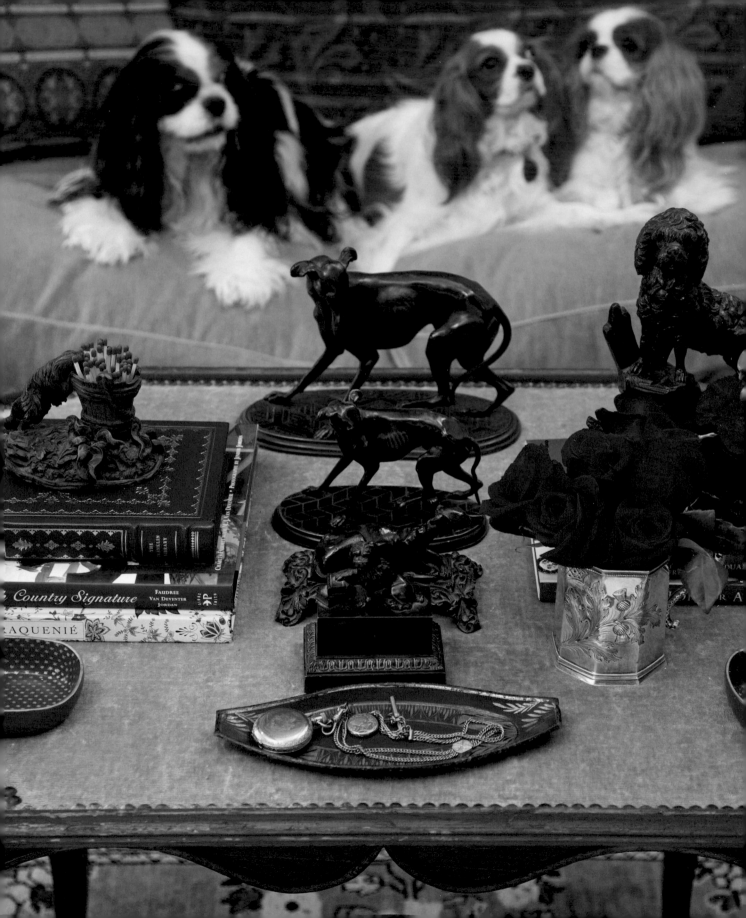

Charles' Cavaliers watch over a collection of bronze
dogs displayed on a rare upholstery-topped table.
It's a heady mix of color, a touch of chinoiserie, and
oh so very French.

Be Quill My Heart

Jenifer is collection crazy. Here she groups quill boxes, antique English horn beakers, African porcupine quills, and antique books. What gives it cohesion is the warm sepia tone. It's a still life of flea market memories.

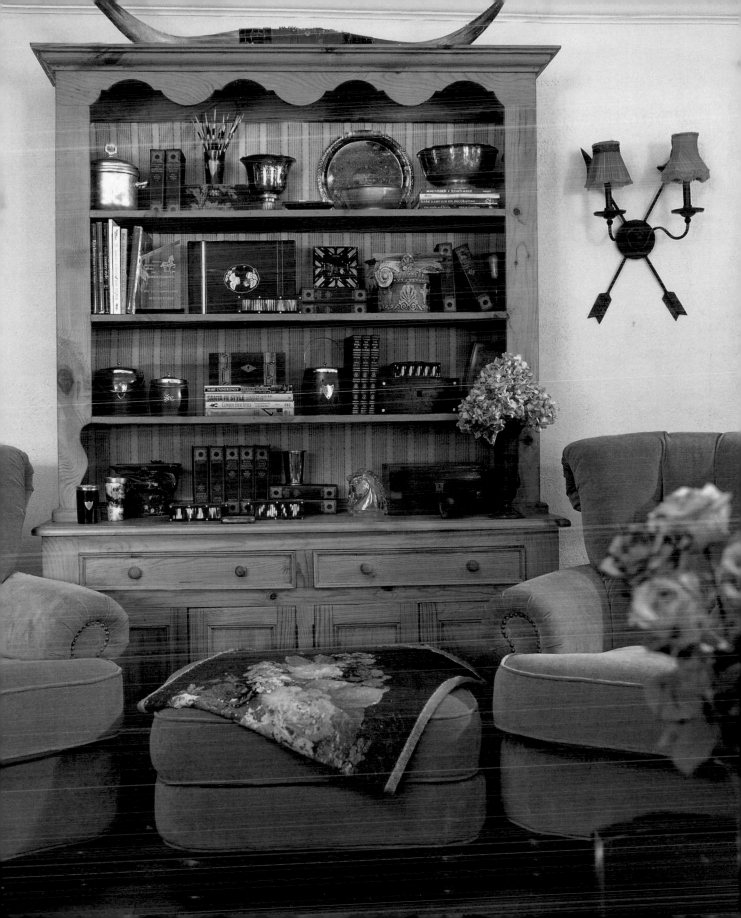

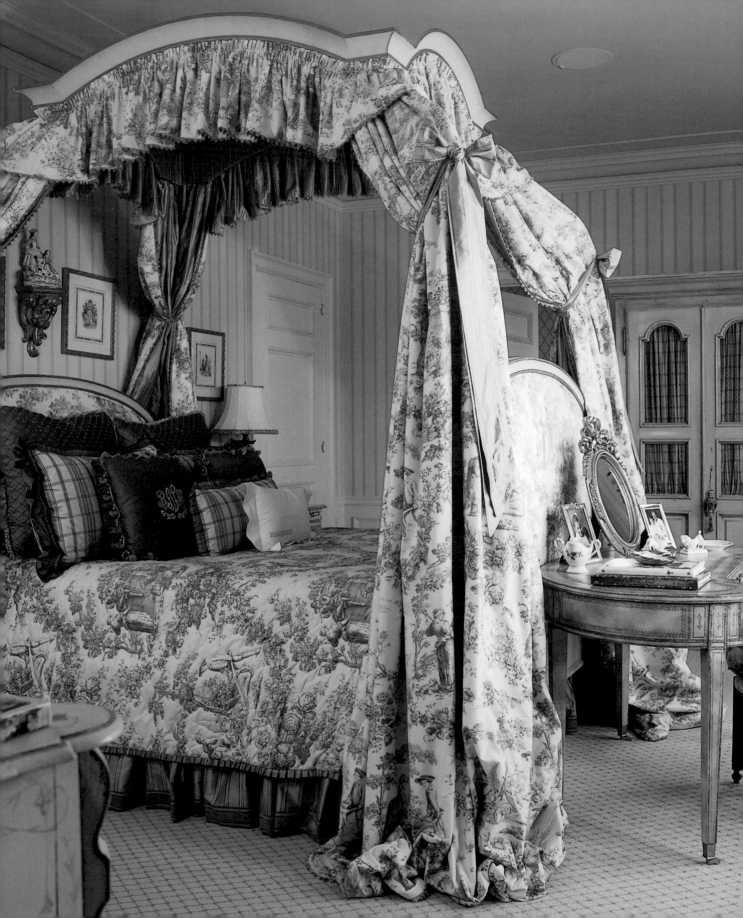

Toile·la·la

Charles is a believer in 'more is more', and that is certainly evident in this girl's room. Enveloped in Brunschwig & Fils 'Sonnet', what young (and not so young) girl wouldn't swoon over this French Country look? Find a fabric that you love and indulge. Sweet dreams!

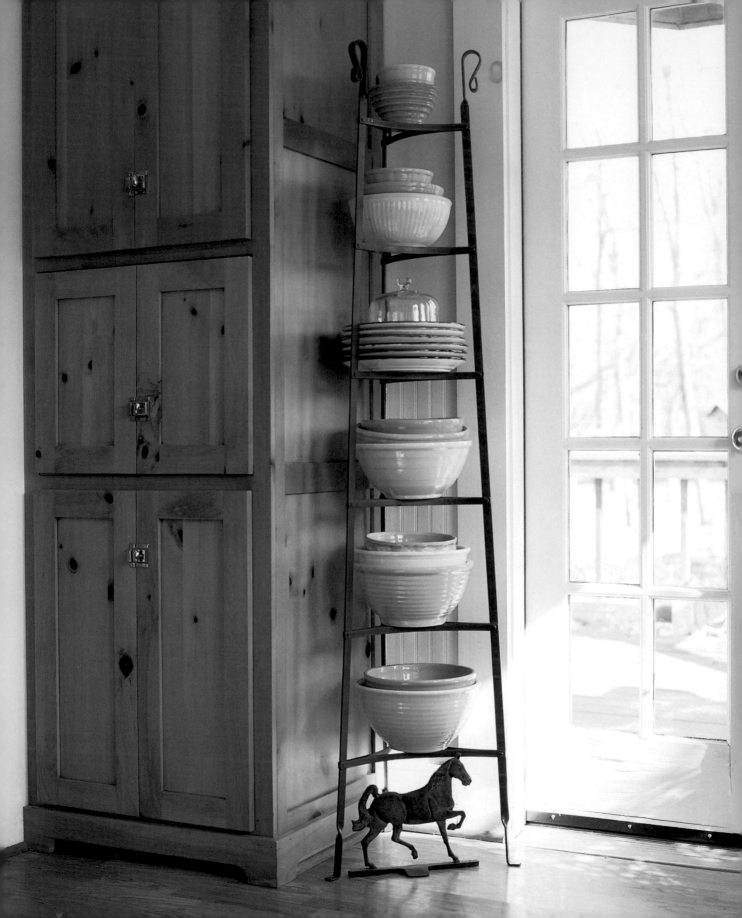

STACKED

What to do when you have more stuff than space?
Think vertical. In Jenifer's kitchen, she uses a tall plate
stand to store her vintage bowl collection. Besides
being a smart use of what would be dead space, it's
super handy and a great look.

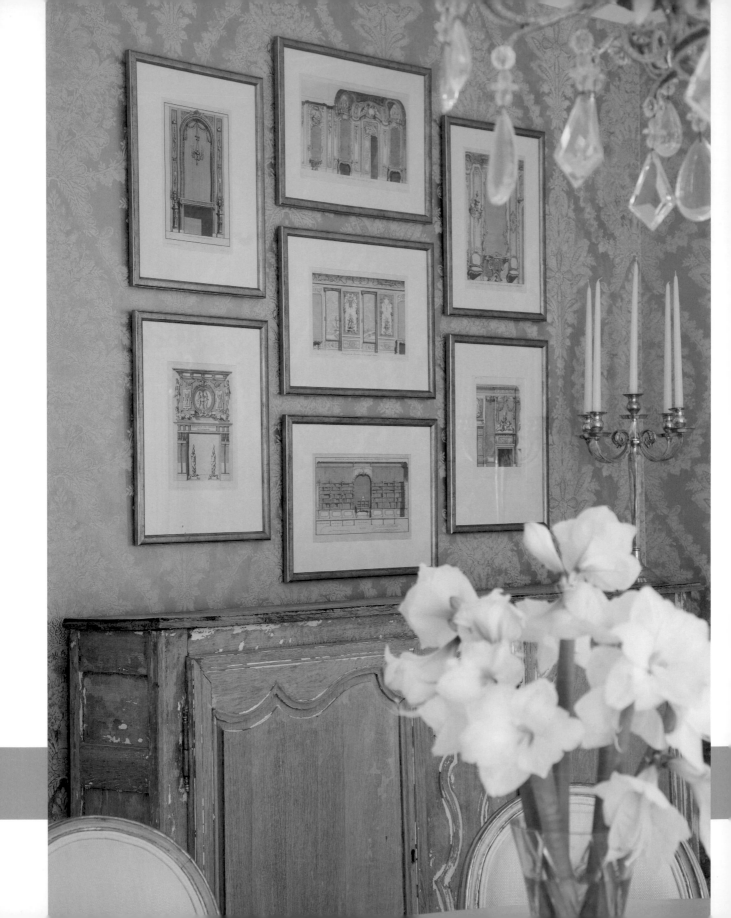

Framed

Gail groups this series of framed lithographs
together, giving them the impact of one large
fabulous piece. Arranging art is an art in itself.

Hide & Sink

Denise mixes materials and textures in this master bath for a look that's both organic and sophisticated. She pairs a vintage French vanity with a stone vessel sink. Then she warms it up with a cowhide, adding comfort underfoot. It's old. It's new. It's earthy. It's fabulous!

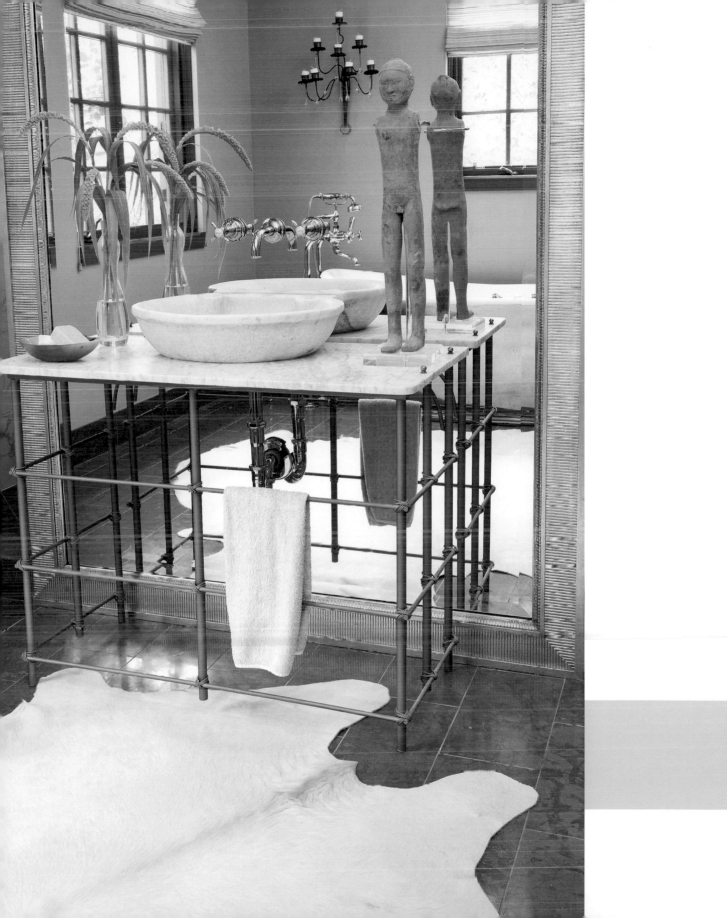

Scarf it up

Talk about making a big statement in an inexpensive way! Jenifer frames a vintage silk scarf to create a striking piece of art. And it gets even better. She bought the scarf on Ebay for $1. That's first-class shopping!

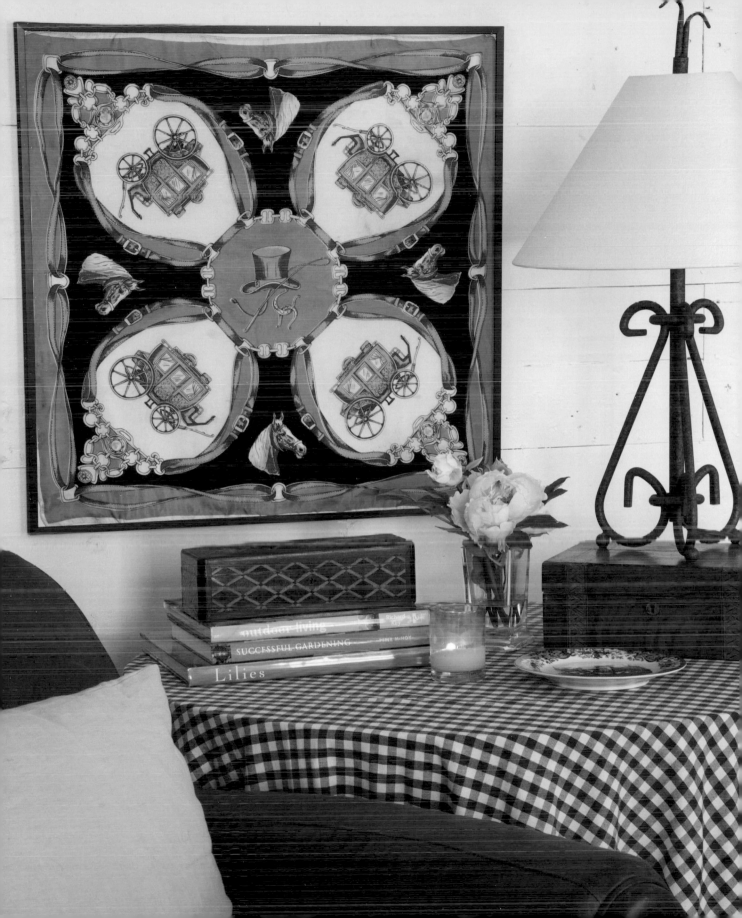

Dog Day
AFTERNOON

Dogs welcome here! Charles designed this back entry with old world appeal, rustic yet rich. It's life in the country with a wink to dog lovers. All so convenient, it invites a long walk with man's best friend. *That's* a real doggy treat!

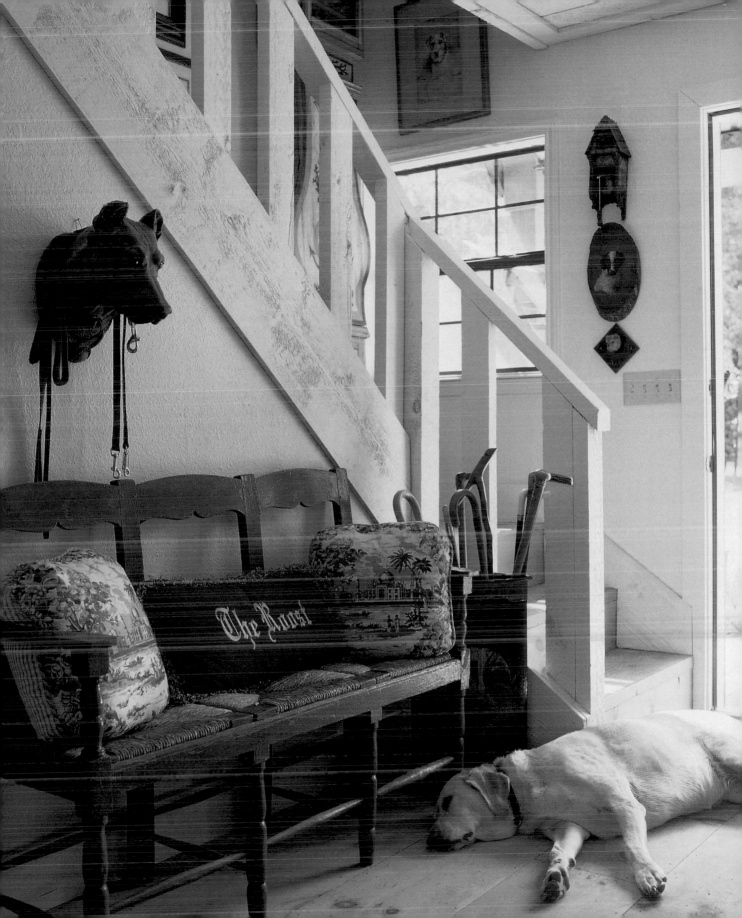

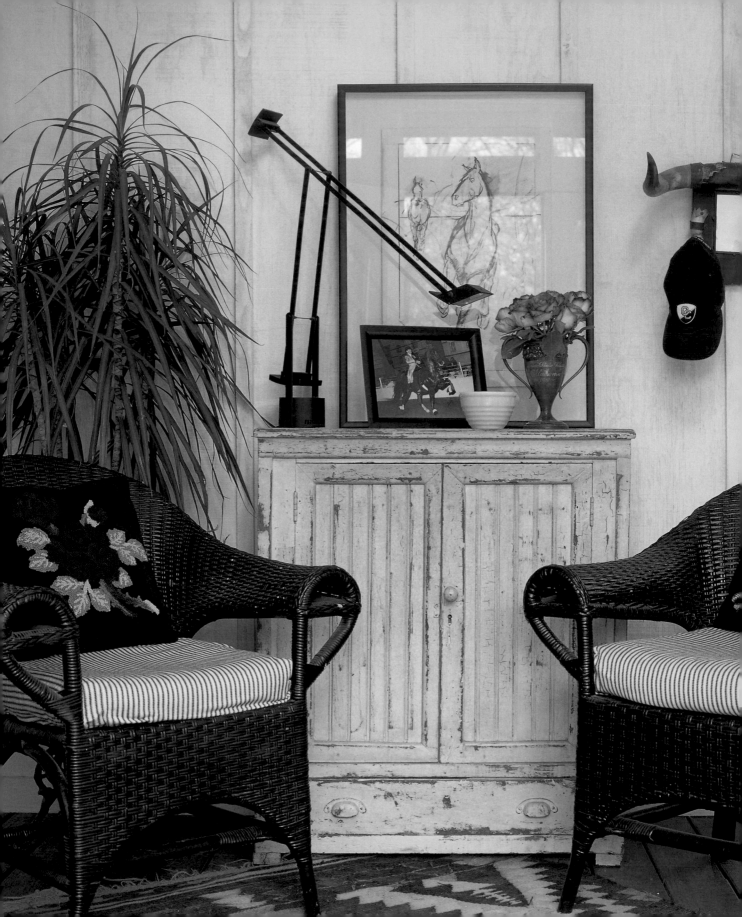

What's love 💋 got to do with it?

Everything!
Jenifer honors her beloved Johnny G in a charcoal by
Donna Howell Sickles, setting it off with a rose filled
loving cup. Vintage ticking and a weathered cabinet say
country – while the Tizio lamp and the use of
restraint say modern. She's a modern country girl at heart.

You ANIMAL You!

Charles makes a powerful statement in this entry with an antique chest, a charming pair of lamps, and action from the zebra rug underfoot. But it's the painting, seeing eye-to-eye with Honest Abe, that gives it dramatic punch. And that's the truth.

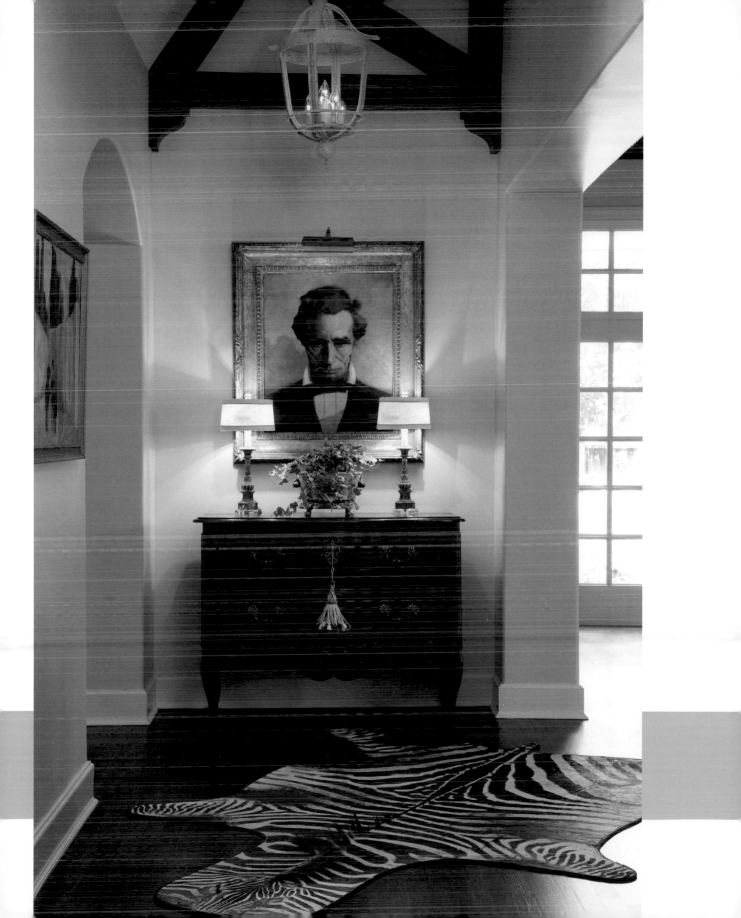

LOOKING FOR SOMEONE?

Charles Faudree
www.charlesfaudree.com

Denise Macey
Denise Macey Design LLC
www.denisemaceydesign.com

Gail Plechaty
Real Simple Design
www.gailplechaty.com

Jennifer Spak
Jennifer Spak Designs
jenniferspakdesigns@gmail.com
214.704.5493

Annie Uechtritz
Otter and Olive Antiques
otterandolive@gmail.com
214.608.8565

Andre Walker and David Simmons
Walker Simmons Designs
www.walkersimmons.com

Jenifer Jordan
Jenifer Jordan Photography
jeniferjordan@aol.com
918-804-8410

Hilary Rose
H. Rose Inc,
Hroseinc@yahoo.com

Joseph Taylor
JoeTaylorArt.com
josepht280@aol.com

Patt Taylor
patttaylor@aol.com